TROPE

IN THE
ARENA

A HISTORY *of* AMERICAN
PRESIDENTIAL
HOPEFULS

Peter Shea & Tom Maday

TROPE

To my wife Petia and my son Peter – in deep love and gratitude for their patience with my desire to spend so much time these past few years in the company of forgotten men. Rest assured, my family's support will never be forgotten by me.

Peter Shea

Dedicated to those Americans who have unselfishly joined the political fray, helping to ensure the ongoing success and stability of our ever-fragile republic.

Tom Maday

CONTENTS

MICHAEL DUKAKIS

Former Governor of Massachusetts
1988 Democratic Nominee for President

FOREWORD

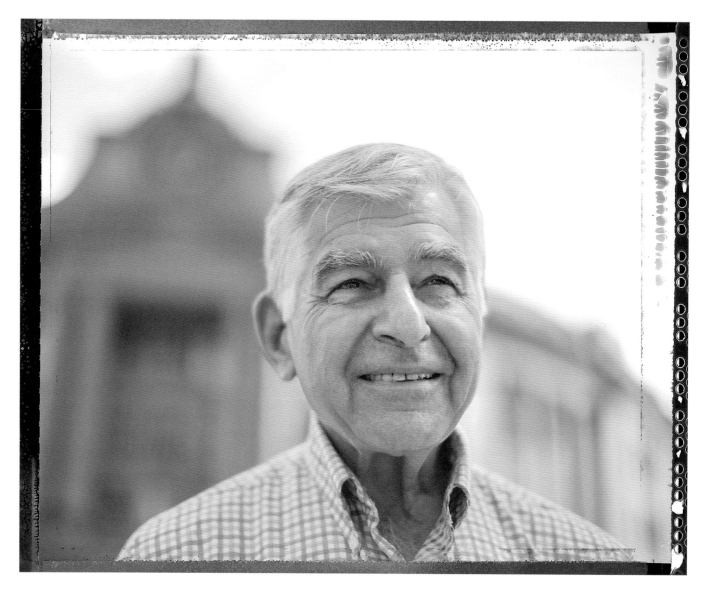

Michael Dukakis in front of the South Station Transportation Center | Boston, MA

Nothing is more exciting – or more demanding – than a candidacy for the presidency.

I had been active in politics for more than twenty-five years before I ran for national office. I started in local government while still in law school, then served four terms in the Massachusetts legislature before taking a shot at statewide office. Kevin White and I lost that race for governor and lieutenant governor in 1970, but it put me in a position where I could seriously challenge the incumbent attorney general and former Speaker of the House for the Democratic nomination for the governorship. I successfully beat him, and then the incumbent governor, and was elected governor in 1974.

After losing the primary when I ran for re-election in 1978, a particularly painful loss, I learned a lot and came back in 1982 to beat the guy who has beaten me in 1978. In 1986, I was elected to an unprecedented third term. In short, I had a lot of politics and electioneering under my belt when I made the decision in early 1987 to take a shot at the Democratic nomination for the presidency.

On the other hand, no matter how much experience you have politically, nothing quite prepares you for the challenge of seeking the presidency. For one thing, you are running in fifty states, not just one. For another, you can't possibly develop the kind of relationship you can often create with your constituents at the state level. I had a good ten years to do that as governor before 1987. Trying to do it in a year and a half of campaigning across the country is exceedingly difficult.

That doesn't mean you don't try. Starting from a very low point in the national polls – I think I was at about one percent when I started – we put together what turned out to be a very effective organization that won the Democratic nomination and put me on the road that I hoped would take me to the White House.

All of which raises the interesting question of why one would run for the presidency in the first place. I had fought my way back from the devastating loss of the governorship on my first try for re-election to regain the office. Massachusetts, which had been an economic basket case when I first ran for governor, was now "the Massachusetts miracle." Unemployment had dropped by 1987 to an almost unheard-of 2.4 percent. I loved my job and the ability it gave me to help lift my state and its people to new heights; to begin the revival of dozens of older urban communities; to expand its park system; to make its schools the best in the nation – in short, to do all those things that most of us, regardless of party and political philosophy, hope we can do in positions of political leadership.

And it gave us the chance to destroy some commonly held myths as well. In fact, good people produce good results. We could stop wasteful and misguided highway construction and invest those funds in a first-class metropolitan transit system. And we could put the lie to the notion that there were some among us who were simply hopeless – the "underclass," they were called – who just were incapable of living productive lives. Our welfare to work program was putting 15,000 welfare mothers to work every year, seventy-five percent of whom never saw welfare again.

Why, then, leave a job you love for the risk and uncertainty of taking on the toughest political contest any American can ever contemplate?

Obviously, it depends on the individual involved. For some, it is a critical period in the history of one's country that demands that at least some of us with prominence in public life believe we can help to make a difference. For others, it is critical issues like economic reform or millions without health

care or a sense that our country could do more with what it has and that we might help to make things a lot better. I'm not a fan of his administration, but I have no doubt that Donald Trump genuinely believed that he could build a stronger economy and a better life for the American people by running, winning and serving in the White House. In my case, there was another very strong factor involved. Not only had the Reagan administration contributed mightily, in my judgment, to a serious and potentially damaging polarization in American politics – the consequences of which we are still living with – but we discovered in the course of the Iran-Contra scandal that the White House and its minions were deliberately breaking the law, supporting with arms and equipment rebel elements in Nicaragua after Congress had specifically prohibited them from doing so, and lying about it while shredding documents in the basement of the White House.

That was something that neither I nor any other American citizen should have to tolerate, and so, with the blessing of my family and without whose blessing I would never have run, I threw my hat in the ring.

Unfortunately, only one person can win the presidency at a time. And that somebody was not me. Fortunately or unfortunately, we do not have a parliamentary system in which the leader of the party that loses continues to be deeply and actively involved in important positions of political leadership and has an opportunity to come back a few years later and try again. With rare exceptions, it's a question of one time only.

So then what? Does one simply retire from the field and become a lobbyist? Join a big law firm and live well? Each nominee who loses faces that problem. And if you have dedicated your life to public service, it seems to me to be a

terrible waste of talent and leadership to simply say to our losers, thanks and enjoy the rest of your life in some other capacity.

Of course, the loser has to think seriously about what kind of role he or she wants to play. During what I often referred to as my "involuntary sabbatical" from the governor's office, I had the opportunity to teach at the Kennedy School of Government at Harvard and to develop some ability to teach future public servants. For me, then, it has been primarily teaching them while remaining fully engaged in public life – especially on the major issues I care about, like health care and transportation and, more recently, international issues. For others it could be more public service in appointed office or a leadership position in an important nonprofit organization.

Whatever it might be, it seems terrible to me to relegate our losing nominees to the sidelines. They have much to offer. We should take advantage of that.

Losing, needless to say, was a bitter disappointment. I had been campaigning virtually nonstop for a year and a half while still trying to provide my state with the kind of leadership I thought it needed during a period of great economic success. I was criticized occasionally for spending too much time at my job, but I felt strongly that one of my strengths was my performance as governor, particularly on the economic front, and sacrificing that during the campaign would have been both dumb politically and not fair to my Massachusetts constituents, who may have been enthusiastic about my presidential candidacy but expected me to do my job as governor at the same time.

But losing is not fun. For one thing, I felt badly about disappointing the thousands of Americans who had worked so hard to get me elected. I felt that particularly strongly because we had so many young people in the

campaign, and I did not want to see them turn away from politics because of a painful loss.

Life goes on, and the work of running and governing continues apace. My friend Bill Clinton had the good sense to go after the presidency in 1992, defeating George H.W. Bush in part because Bush broke his "read my lips" commitment not to raise taxes. Clinton helped put the country back on track with a full employment economy and a quarter of a trillion dollar federal budget surplus. Why the Democratic Party couldn't elect Al Gore with an overwhelming margin in the 2000 election is a story for another day, but we seem to find ourselves in a historic pattern: Republicans insist that tax cuts for the rich are the key to our economic hopes, but those cuts only balloon deficits. Then a Democratic president comes along and straightens out the mess, only for the electorate to again elect a Republican who wants to cut taxes for the rich.

In the meantime, we have serious issues to face as we assess the way we elect our presidents. How long will we continue an Electoral College system that in 2016, for the second time in sixteen years, elected the candidate with fewer popular votes? How do we return to a political system in which leaders understand that achieving consensus on the important issues of the day is the only way to move this country forward? Why are we still debating the details of the Affordable Care Act when over ninety percent of the American people believe that working Americans and their families should have decent and affordable health care?

These questions deserve serious answers, and it will be up to future presidential candidates to wrestle with them while working hard to win

elections. In the meantime, I believe those of us who tried and failed should not retreat from the arena. Despite our losses, we have much to contribute to making America and the world better places.

For me that has meant nearly three decades of teaching young people at Northeastern and UCLA and encouraging my students to seek careers in public service. As I tell them all the time, there is nothing more fulfilling or satisfying in this world than being in a position where you can make a difference in the lives of your fellow citizens.

JAMES KELLY

Professor Emeritus of Sociology
Fordham University

∞

INTRODUCTION

"He who has never failed somewhere,
that man can not be great. Failure is
the true test of greatness."

Herman Melville

A book about presidential candidates who lost their elections? What could be a more un-American topic? Don't Americans instinctively recoil from losers? Don't we identify with phrases like "the best and the brightest" or, more recently, "make America great again?"

The response, of course, can be gleaned in the quotation from which this book derives its title, the sage observations of that quintessential American, Theodore Roosevelt:

"The credit belongs to the man who is actually *in the arena* . . . who strives valiantly; who errs, who comes short again and again, because there is no effort without error and shortcoming . . . if he fails, at least fails while daring greatly, so that his place shall never be with those cold and timid souls who neither know victory nor defeat."

The quotation comes from a speech Roosevelt delivered in 1910, whose title it should be noted was *Citizenship in a Republic*. Roosevelt's theme was that a successful republic requires citizens who strive to win, even if they risk great failure. Failure is not fatal to a country's fortunes – but passivity and meekness are.

From time to time, we have forgotten this insight, and the price for this forgetfulness has been costly. America prolonged the war in Vietnam for close to a decade after policy analysts concluded it was unwinnable, because we could not bear the thought of losing. Fear of defeat made the ultimate failure of that war all the greater.

Bearing this in mind, Americans should honor and remember those who failed in pursuit of a great goal; in this case, the presidency of the United States. What's more, readers will find a treasure trove of wisdom from these largely forgotten men. Al Smith – trounced in the 1928 election, but the winner in the twelve largest cities by anticipating FDR's progressive role for government – remarked, "The American people never carry an umbrella. They prepare to walk in eternal sunshine." Smith intuitively understood that the American character is animated by the ability to move forward into the unknown, protected only by a deep faith in a bright future.

Another feature of this book is its ability to surprise the reader. Barry Goldwater, remembered best as the archconservative soundly beaten by Lyndon Johnson in 1964, supported the right of openly gay men and women to serve in the military. At a time when America seems more politically polarized than it has been in decades, it is good to be reminded that people

are more complex than we realize, which allows possibilities for agreement and solidarity even across deep ideological divides.

But this book isn't solely about failed American presidential candidates (sometimes referred to as "also-rans"). It is about the monuments to these men, and one woman. Shea and Maday want readers to ponder the role of public memory in American life: how it shapes the way Americans see themselves and their past, and how it might guide an understanding of who they may yet become.

When the United States began, its leaders deliberately followed a neoclassical model. Among the practices copied from the past was the creation of marble and bronze figures commemorating men of great standing, both to honor their contributions and to provide the citizens of a young country with role models to emulate. Apart from statues, new settlements and towns were often named after the republic's great figures.

As time passed, however, neoclassical and romantic monuments were replaced by those that were modern and industrial. It became simpler, and presumably cheaper, to forego civic art and substitute public works in their place. Bronze busts (DeWitt Clinton) gave way to buildings (James Blaine), mountains (John C. Frémont) to motorways (Thomas Dewey). Reverent remembering was replaced by terse acknowledgment. Civic commemoration was largely a lost art.

And then a sea change occurred. During the years that this book was being created, monuments to political and military figures went from being of interest only to pigeons and squirrels in city parks to becoming centerpieces in a cultural battleground. It was as if there was a sudden,

startled awareness of the power of memorials to shape both the present and the future. Look no further than the removal of John C. Calhoun's name from a college at Yale University – and its replacement by the computer programming pioneer Grace Hopper – to see how monument design and designation reflects shifts in public values and sentiment.

This is a welcome development. If we begin to embrace the vision Theodore Roosevelt put forth in his 1910 speech, we can grasp the value of honoring all who step into the arena of presidential campaigning and learn from their examples. Imagine for a moment how educational (and much more interesting) Disney World's Hall of Presidents would be if the successful presidential candidates were joined onstage by their rivals. Gone would be the serene (and smug) expressions on their animatronic faces. Thomas Jefferson would have to deal with a discomfiting glare from Aaron Burr. Donald Trump would furiously ignore a rueful expression from Hillary Clinton, with her husband Bill studiously avoiding looking at either of them.

Finally – and by no means least – the authors' judicious verbal-pictorial treatment of American presidential hopefuls can contribute to a healthy self-reflection for the rest of us. For Americans, reading about our presidential also-rans, how some handled their defeats creatively and how some never psychologically recovered, should prompt readers to think more deeply about how they might creatively respond to their own setbacks. Hopefully, the life stories described in this book will help readers, as they contend within the arenas of their own lives, become the life-embracing strivers of Roosevelt's great speech. May they discover, as Robert Frost once said, " . . . that the utmost reward of daring should be still to dare."

IN THE
ARENA

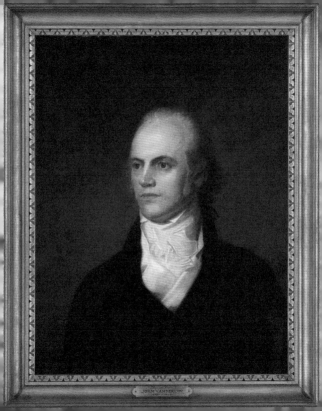

JOHN VANDERLYN

AARON BURR

Born: 1756 Died: 1836

1800
DEMOCRATIC-REPUBLICAN

Defeated by:
THOMAS JEFFERSON

THE ASSASSIN

He was the grandson of Jonathan Edwards, one of colonial America's most revered spiritual leaders. In war, Aaron Burr was a capable soldier and intelligence officer in the Continental Army. He became a successful lawyer and businessman, helping to found a bank that would one day become part of Chase Manhattan. A skilled propagandist, he is credited by some with inventing modern political campaigning. Aaron Burr was an advocate for women's rights and anti-slavery causes long before those positions became popular. He held public office as a state attorney general, as a senator, and as vice president of the United States.

Yet, for all the roles he played, there is only one identity for which Aaron Burr is remembered – that of a murderer.

Aaron Burr had a splendid beginning in life, born in Newark in 1756 to the Reverend Aaron Burr and his wife Esther, Jonathan Edwards' daughter. The Reverend Burr was the president of the College of New Jersey, later to become Princeton University. Once a student there, Aaron Burr originally intended to follow his father into the ministry but shifted to law, studying under his brother-in-law Tapping Reeve, a brilliant attorney who would found America's first law school.

When the American Revolution began, Burr, like many young men, abandoned what he was doing to enlist. He fought in several campaigns, including the Battle of Quebec alongside that other fallen angel of the period, Benedict Arnold. He served briefly on the staff of George Washington, rising to the rank of lieutenant colonel before leaving the Continental Army for health reasons. Washington employed Burr as an intelligence officer, but – canny judge of character that he was – never quite trusted him: "By all that I have known and heard, Colonel Burr is a brave and able officer, but the question is whether he has not equal talents at intrigue." Washington took pride in promoting the careers of talented young men in his orbit, such as Jefferson and Hamilton. In the case of Burr, however, he did the reverse, using his influence to block advancement.

After the war, Burr married widow Theodosia Prevost, who had five children with her previous husband. Only one of the children she had with Burr, a daughter also named Theodosia, would live to adulthood. Burr would see that his daughter received an education equivalent to that which he would have given a son. Theodosia was tutored in Greek, Latin, French, and arithmetic. As a young woman, she married Southern aristocrat Joseph Alston, who would later serve as governor of South Carolina. In addition to his children by marriage, Burr would have children by a woman of color, whose descendants today still bear the Burr family name.

Burr began his political career in the New York Assembly. From there he became New York State's attorney general, then a senator. His Senate race was against Philip Schuyler, the father-in-law of Alexander Hamilton. Burr's defeat of Schuyler probably planted the first seed of antipathy between Burr and Hamilton; until then, the two men had been on cordial terms.

As a protege of Washington, Hamilton was doubtlessly aware of Washington's low estimation of Burr. This gave Hamilton further incentive to treat Burr as both a

political adversary and a man whose character flaws made him a danger to the country. After his first term in the Senate, Burr lost his bid for re-election to Philip Schuyler, and blamed Hamilton's machinations for his defeat.

Burr rejoined the New York Assembly and helped consolidate his power by transforming the Tammany Society, a social club, into a political machine that could influence elections and promote candidates. Burr associated with the Democratic-Republicans faction. However, he also cultivated associates who moved in Federalist circles.

Burr impressed people with his artful manners ("He is the first gentleman in America," wrote one acquaintance). Nevertheless, there was something superficial about Burr that even people who acknowledged his talents noticed. Hamilton biographer Richard Brookhiser likened Burr to a refrigerator: "bright, cold, and empty." An apparent absence of deeply held convictions combined with his great ambition – and a continual pursuit of money to finance a lavish lifestyle – alienated Burr even from people who recognized his ability.

The peak of Burr's political career came in 1800, when he made an attempt for the presidency. John Adams, a Federalist, was running for re-election. However, his natural advantage as an incumbent was damaged by the publication of a private letter written by his erstwhile political ally Alexander Hamilton, in which Hamilton scathingly listed Adam's supposed defects. This gave an advantage to the Democratic-Republican party represented by candidates such as Thomas Jefferson and Burr.

Under election rules at the time, the person who received the second most electoral votes became vice president. Burr and Jefferson were initially tied. Given the depths of detestation that Thomas Jefferson inspired in Federalist electors, Burr might have easily won on the second ballot. But Hamilton used his considerable influence to persuade many Federalists to vote for Jefferson, whom Hamilton argued was less dangerous than Burr. Hamilton had come to regard Burr as an "embryo-Caesar," someone unprincipled enough to undermine the fledgling republican government if he saw a path to greater power for himself.

Burr achieved the vice presidency, but was shut out of real political influence (in

the manner of most vice presidents). Jefferson, another protege of Washington, had as little regard for Burr as Hamilton did. By 1804, when Jefferson ran for re-election, the law had changed, allowing the vice president to be selected by the president. Jefferson chose George Clinton of New York, and this repudiation damaged Burr's political career still further.

That same year, Burr's simmering conflict with Hamilton came to a final boil when Burr and Hamilton exchanged letters over remarks that Hamilton had made against Burr. Burr decided that it was time to neutralize Hamilton with the expediency of a duel. Their confrontation in the early morning of July 11, 1804, in Weehawken, New Jersey – the most famous duel in American history – ended the mortal life of one man and the political life of the other.

Burr was able to escape legal consequences of the duel, but it finished off any chance he might have had of attaining power again. His last great act on the stage of history was to involve himself in a scheme to incite a revolt in Spanish-held territories west of the Mississippi, in order to create another new country – in which he, of course, would play a leading role. When the plot was revealed, Jefferson used it as an excuse to arrest Burr for treason. The charge was hard to sustain, since it did not actually involve acting against territories directly held by the United States. There was also little evidence to implicate Burr in actions which met the legal definition of treason.

Burr was cleared, but the ruin of his reputation was complete. He left to spend some years in Europe before returning to the United States to quietly practice law in New York and – at the age of 77 – to marry a wealthy widow. Burr, however, had not reformed his spendthrift ways, and the widow divorced him on the grounds that he had squandered her fortune. Their divorce became final on the day of Burr's death in 1836.

That the last legal action involving Aaron Burr was the dissolution of an intimate relationship is suggestive of a pattern that followed him throughout his career: attraction followed by disillusionment, distrust and finally revulsion, requiring a permanent separation. It wasn't Burr's vaunting ambition that alienated his political peers; all had ambition and no small amount of personal vanity. For the most part, however, men like Adams, Jefferson, Madison, and Hamilton were able

AARON BURR

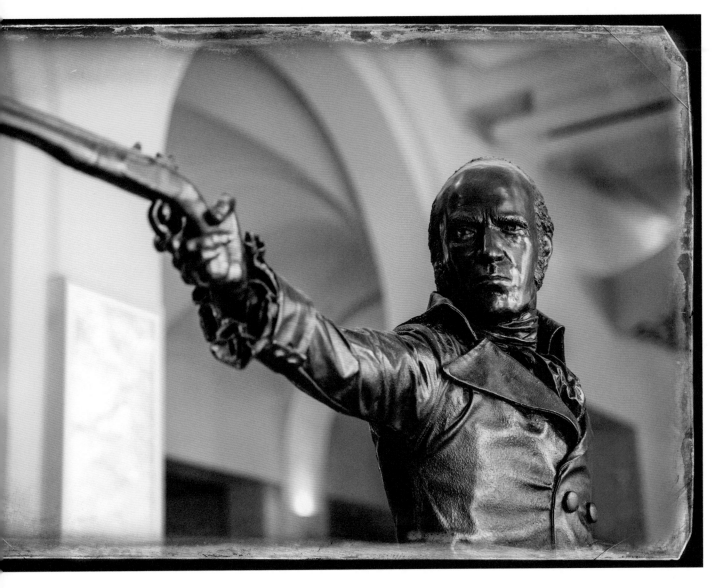

Life-size bronze statue, New York Historical Society | New York, NY

to hold their demons in check while building a new nation. Burr, like his colleague Benedict Arnold, lost the struggle between egotism and patriotism. In addition, his killing of Hamilton, a fellow member of the founding generation, affixed a fratricidal element to his reputation, marking him as an American Cain.

It is rare to find a monument that compels onlookers to reflect on the subject's capacity for violence. Burr's statue depicts him holding the famous dueling pistol in hand, arm extended and ready to pull the trigger. It reminds us that the defining act of the life of this once-promising man was a killing.

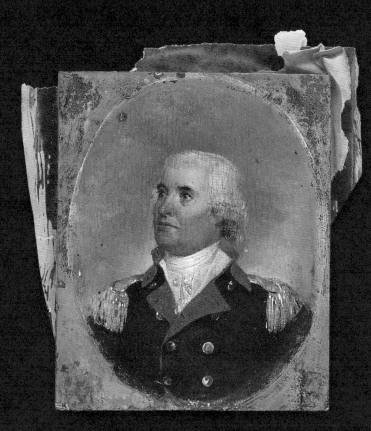

CHARLES COTESWORTH PINCKNEY

Born: 1746 Died: 1825

1804 & 1808
FEDERALIST

Defeated by:
THOMAS JEFFERSON
& JAMES MADISON

IN THE SHADOW OF GIANTS

Charles Cotesworth Pinckney was the earliest example of a type seen throughout the history of American presidential campaigns – capable but colorless. Born into the gentry in South Carolina, he served as a major general in the Revolutionary War and was a friend and confidant of Washington. He served as a minister to France for the United States and was a respected member of the early American political establishment. Like Washington, he belonged to that early class of Southern-born aristocrats who could balance both regional and national loyalties (unlike, say, John C. Calhoun).

Pinckney was nominated as the candidate of the Federalist Party in 1804, though it was widely understood that he had little chance against the far more popular Thomas Jefferson. The Federalist Party again promoted him as their candidate in 1808, but he lost again, this time to James Madison. Pinckney devoted the remainder of his life to practicing law and tending his plantation. He died in 1825.

Pinckney is one of the more commonly overlooked members of the "founding father" generation. His misfortune in politics was to be overshadowed by his better-known rivals. His tombstone acknowledges both his individual achievement as a member of the founding generation and his relationship with Washington. It reads, "One of the founders of the American Republic. In war, he was the companion in arms and the friend of Washington. In peace, he enjoyed his unchanging confidence."

Charles Pinckney seems, at best, a minor figure in the drama of early American history. In every play, however, there are secondary characters, like *Hamlet*'s Horatio, performing actions that take on greater significance as the story progresses. In 1788, during debates over the adoption of the Constitution, Pinckney raised an objection to the inclusion of a Bill of Rights. Such documents, he noted, often begin with the observation that men are born free. Pinckney, a slave owner, knew full well this was not true in the United States, and said so in the South Carolina House of Representatives. According to one observer, Pinckney expressed concern that, should a Bill of Rights be adopted (with its implied assumption that all men are born free), that "we should make that declaration with a very bad grace, when a large part of our property consists in men who are actually born slaves."

Pinckney discerned the very problem that would forever haunt the American republic – the gap between our elevated rhetoric and our baser, selfish actions. Pinckney is archetypal of men of the founding generation, like Washington and Jefferson, who tried to live with contradictory beliefs about freedom. The country they created continues to grapple with the legacy of this division.

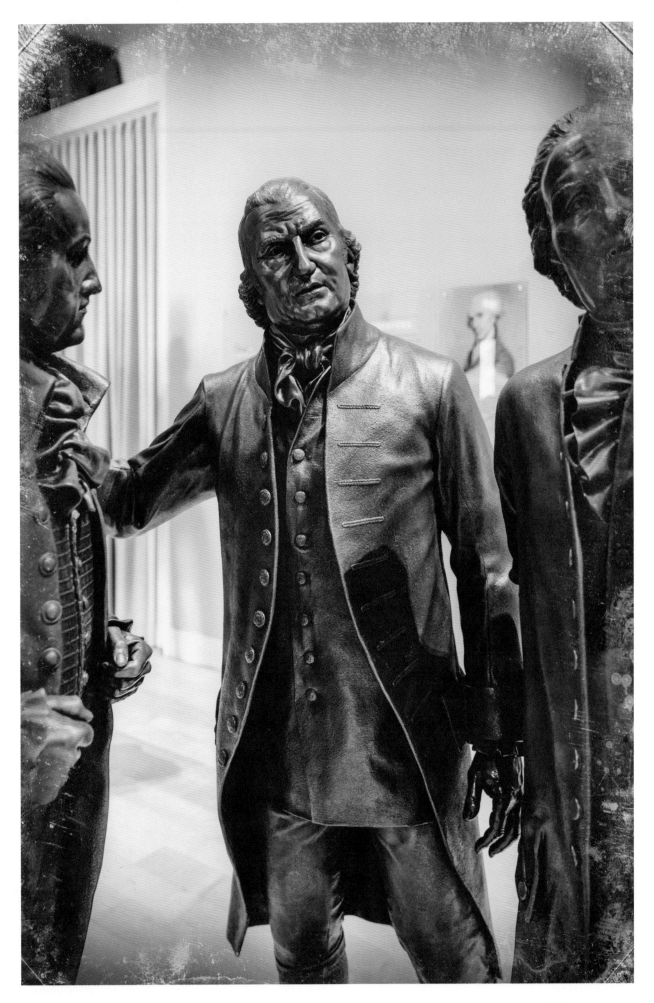

National Constitution Center | Philadelphia, PA

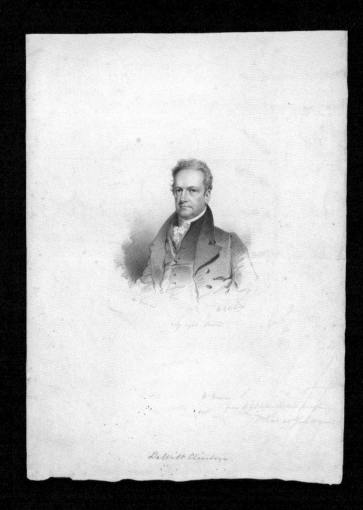

DeWitt Clinton

DeWITT CLINTON

Born: 1769 Died: 1828

1812
FEDERALIST

Defeated by:
JAMES MADISON

CANAL BUILDER

Outside of New York City, the name "DeWitt Clinton" would likely not elicit a reaction. Inside the city, the name is best associated with a well-regarded public high school in the Bronx from which many famous people (James Baldwin, Stan Lee, Richard Avedon) have graduated. This is a true misfortune, as Clinton's signature achievement was the creation of one of the most important public works in American history – the Erie Canal. The Erie Canal was to the early nineteenth century what the railroad was to the late part of that century, or what the national highway system was to mid-twentieth century America: a key element in advancing the travel and interstate commerce which is the lifeblood of the American economy.

DeWitt Clinton was born in 1769 into a family prominent in early America. His father was a major general in the Revolutionary War, his brother was a member of the House of Representatives and his uncle, George Clinton, served as governor of New York and the fourth vice president of the United States, serving under both Thomas Jefferson and James Madison. DeWitt Clinton began his political career in the New York legislature, then was elected by the legislature to the US Senate. Unhappy in Washington, D.C., he returned home and was appointed as the mayor of New York City. Like many public-spirited figures, he participated in a number of organizations, such as the New York Historical Society and the American Academy of Fine Arts.

After his uncle failed to achieve a nomination for president, attention turned to DeWitt Clinton as the natural inheritor of his uncle's political supporters. In the 1812 election, Clinton the younger received support from the Federalist Party. However, that party was already in a state of decline, with its influence largely restricted to the Northeast, and Madison won a clear victory over Clinton.

Unlike many unsuccessful presidential candidates, Clinton's best years were still ahead. Repeatedly re-elected as governor of New York, he was one of the chief political architects of the Erie Canal. At the early stages it was seen as an impossibly expensive project that would not merit the cost – referred to as "DeWitt's Ditch." As it neared completion, however, it began to be seen as one of the more foresighted public works projects, establishing a precedent for initiatives that crossed state boundaries and helping to cement a sense of national (as opposed to state) identity.

Clinton continued his career as a public servant until dying suddenly in 1828 while still serving as New York governor. Ironically, despite his distinguished career, Clinton had little money at his death. His family needed to rely on charity to pay outstanding debts he had left behind.

While Clinton received a lavish public funeral, his family could not pay for a decent interment, which resulted in his body residing for several years in the family vault of a friend. When his family could finally afford a proper burial, DeWitt Clinton was interred at Green-Wood Cemetery in Brooklyn.

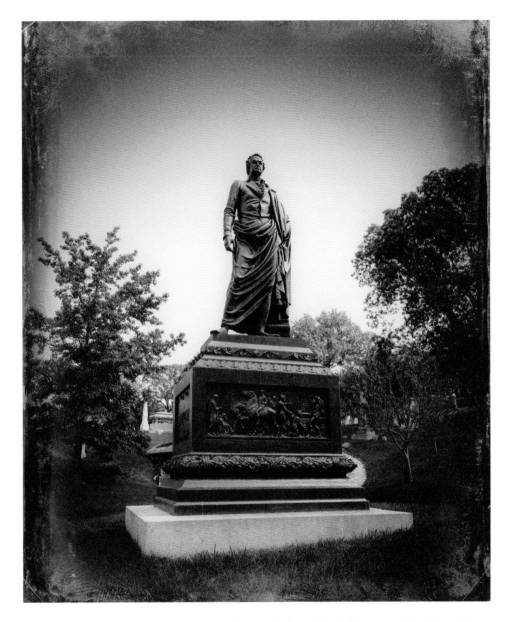

Monument and grave in Green-Wood Cemetery | Brooklyn, NY

Above his tomb is a bronze statue which presents DeWitt Clinton as a standing figure in the neoclassical mode. It is an aesthetic approach uniquely suited to Clinton, a man devoted to civic duty in the manner associated with great figures of the Roman republic like Cato and Cicero. Clinton's foresight in promoting the Erie Canal, despite the innumerable obstacles, ensured his state's economic future. He would have agreed with Cicero: "The greater the difficulty, the greater the glory."

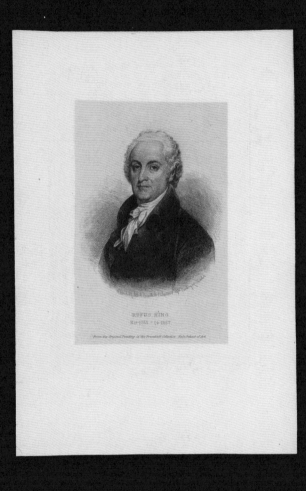

RUFUS KING
Nat 1755 - Ob 1827

From the Original Painting in the Trumbull Collection Yale School of Art.

RUFUS KING

Born: 1755 Died: 1827

1816
FEDERALIST

Defeated by:
JAMES MONROE

THE LAST FEDERALIST

Having lived so long with only two significant political parties, modern Americans are unaccustomed to seeing a major party disappear. Yet that is what happened in the early nineteenth century with the disintegration of the Federalist Party, the first major political party formed in America.

Founded largely by Alexander Hamilton, it was the first expression of American-style political conservatism. George Washington, while outwardly nonpartisan, was sympathetic to its pro-business, strong federal government philosophy. John Adams was the only president officially associated with the Federalist Party. John Marshall, the first Chief Justice of the Supreme Court, was a devoted Federalist. However, the Federalist Party was too closely linked with the Northeast and failed to garner sufficient support over time in other parts of the country.

1 8 1 6

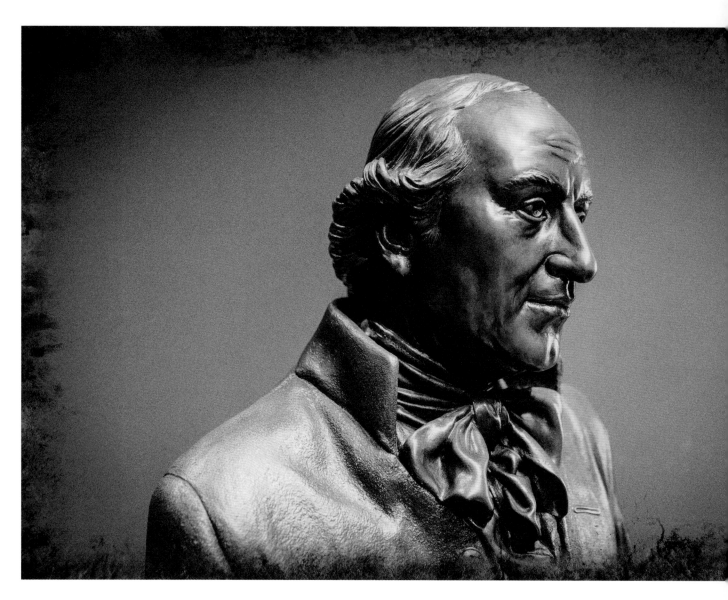

National Constitution Center | Philadelphia, PA

RUFUS KING

The party's power was on the wane in 1816 when they put forward their last presidential candidate, the honorable Rufus King. King had been the vice-presidential candidate on the ticket with Charles Cotesworth Pinckney of South Carolina in 1804 and 1808. A successful lawyer and the son of a merchant from Massachusetts, King was the quintessential Federalist in temperament and background. He had served as a senator and as US Minister to Great Britain. King was in the Senate during the 1816 election, returning to it after losing to James Monroe in the presidential contest. In 1825, he was re-appointed by President John Quincy Adams as ambassador to Great Britain. He served for a year before ill health warranted his return to America. He died in 1827.

It has become fashionable in some circles to argue that the founders of the United States were driven by narrow self-interest rather than love of country. Such critics would do well to consider Rufus King. During the pre-revolutionary period, an angry mob ransacked the home of King's father Richard, a prominent merchant; they were resentful of the family's prosperity. Embittered, Richard King's allegiance remained with Great Britain when the war began. This attack against the family property did not, however, dissuade Rufus King or his siblings. As John Adams remarked in a letter to his wife Abigail, "It was not surprising that Richard King became a loyalist. All of his sons, however, became patriots."

Perhaps King's greatest accomplishment was as ancestor to a number of prominent descendants, thanks to his five children. Among his notable progeny are Admiral Bill "Bull" Halsey, poet and screenwriter Alice Miller, and tech entrepreneur and creator of CNET Halsey Minor.

Life-size bronze statues of all signers of the Constitution in Signers' Hall | Philadelphia, PA

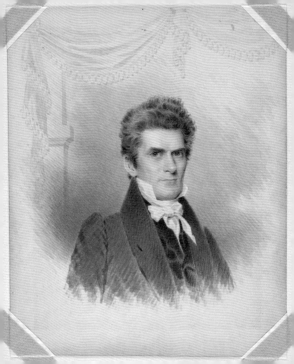

JOHN C. CALHOUN

Born: 1782 Died: 1850

1824
DEMOCRATIC-REPUBLICAN

Defeated by:
JOHN QUINCY ADAMS

THE NULLIFIER

The removal of a man's name from a building is, one supposes, a sort of backhanded compliment to the person whose name is being erased. It suggests that the deceased individual stood for something significant enough to merit a public rejection, a posthumous censure.

John C. Calhoun, the third member of the Great Triumvirate of early nineteenth century senators which included Henry Clay and Daniel Webster, had a college at Yale University named in his honor in 1931, eighty-one years after his death. (Calhoun was valedictorian of the class of 1804.) That honor came during a period when the last veterans of the Civil War were dying and the United States wanted to demonstrate that the wounds associated with that period had truly healed; the Lincoln Memorial had opened ten years earlier.

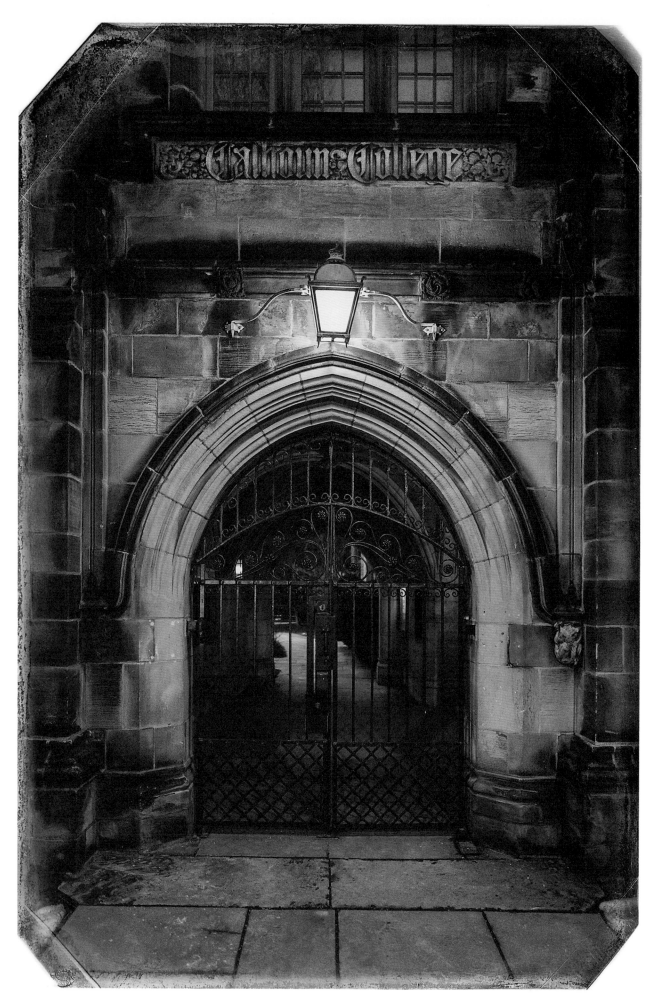

Calhoun College at Yale University, renamed in 2017 to honor Grace Murray Hopper | New Haven, CT

JOHN C. CALHOUN

On February 11, 2017, Yale announced that it was changing the name of Calhoun College to Hopper College in honor of Rear Admiral Grace Hopper, a computing pioneer who, like Calhoun, was a Yale alumnus. In his announcement, Yale president Peter Salovey said the change was appropriate since Calhoun's position as a "white supremacist and a national leader who passionately promoted slavery as a 'positive good' fundamentally conflicts with Yale's mission and values."

That Calhoun, who died in 1850, could become newsworthy in 2017 is an acknowledgment of how significant a force he was in life. For over forty years, he stood as one of the "great men" of the republic – brilliant, unyielding, persuasive in speech and manner, supremely capable in crafting policies in response to the needs of a young, still-growing country with competing regional interests. The United States, which represented an untried political experiment in self-governance, desperately needed men of Calhoun's caliber to support it during its early, uncertain years.

In the early decades of his career, he was one of the foremost advocates of American nationalism. The right of states to secede from the Union was just a fanciful notion, held largely by New Englanders disgruntled with having their robust economy tethered to the comparatively lethargic South. It was – irony of ironies – Timothy Dwight, Yale University president and one of his professors, from whom Calhoun first heard secessionist theory expounded.

Dwight's theories did not appear to influence Calhoun early on. The beginning of his life in politics was marked by an ardent nationalism. During the War of 1812, he led the pro-war faction in the House of Representatives. His Olympian efforts directed towards building America's defensive capacities led him to be called by one colleague, "the young Hercules who carried the war on his shoulders." In 1817 he became Secretary of War under President Monroe. Calhoun understood from his experience that the United States needed a viable professional military and could not continue being heavily dependent on local militias. The war had also impressed upon him the need to speed internal improvements such as roads, in order to facilitate commercial activity so the country could supply its own needs without too much foreign trade.

In 1824, Calhoun made his first go at the presidency. He did not have the electoral votes to win, but he did manage to become vice president under John Quincy Adams. It was during this period that Calhoun began to worry about the incursion of federal power on state sovereignty. The process of congressionally supported internal improvements, Calhoun realized, gave the federal government more power over the states than he had expected. In addition, the growing economic powers of the North, with its proliferating factories and budding industrial might, was beginning to push for the adoption of tariffs that favored Northern development over Southern interests. In 1828, disillusioned with the New Englander Adams, Calhoun joined Andrew Jackson's successful presidential bid and agreed to continue serving as vice president.

Calhoun, however, never meshed well with the volatile westerner. They clashed over Jackson's support for John Eaton, a cabinet member believed to have had an affair with his wife Peggy while she was married to another man (thus offending the propriety of the rest of the cabinet and their wives, who, under the leadership of Calhoun's wife Floride, actively sought to ostracize the couple).

Apart from the tension over personal matters, Calhoun continued to shift from a national perspective to one that concentrated more on the needs and values of his native region. He supported South Carolina's position during the Nullification Crisis of 1832, in which the state challenged federal tariffs that hurt the Southern economy. It was here that Calhoun made his definitive move to champion state sovereignty over federal power. Though the crisis was resolved through compromise, it set the tone for the rest of Calhoun's career. More than any American political theorist before him, Calhoun most fully articulated the principles by which a state could challenge and nullify federal – law including, as a last resort, the right to secede from the Union. From that point forward, he would be seen as the intellectual godfather of the primacy of states' rights and secessionist principles.

As disillusioned with Jackson as he was with Adams, Calhoun became the first person to resign as vice president. He was then elected to the Senate from South Carolina, a position he would hold until his death. Calhoun would make one more run at the presidency in 1844, only to be defeated by James K. Polk, a lesser-

known protege of Andrew Jackson. (Indeed, the number of inconsequential men who ascended to the presidency between 1830 and 1860 is striking. Part of the problem lay in the fact that all the first-rate men were identified with a specific region of the country in the manner of Calhoun, Webster and Clay. This made it difficult to reach consensus around one strong candidate.)

In addition to the doctrine of nullification, Calhoun also differentiated himself by defending slavery not as a necessary evil – the view of many of his contemporaries – but as a "positive good." He wrote:

"I hold that in the present state of civilization, where two races of different origin, and distinguished by color, and other physical differences, as well as intellectual, are brought together, the relation now existing in the slaveholding States between the two, is, instead of an evil, a good – a positive good . . . I hold then, that there never has yet existed a wealthy and civilized society in which one portion of the community did not, in point of fact, live on the labor of the other."

Calhoun did not live to see the outbreak of hostilities between the states, but he foresaw it. The intellectual seeds he had sown in favor of a Southern confederation were beginning to blossom. Before his death in 1850, he wrote of the coming storm:

"I fix its probable occurrence within twelve years or three presidential terms. You and others of your age will probably live to see it; I shall not. The mode by which it will be done is not so clear; it may be brought about in a manner that no one now foresees. But the probability is, it will explode in a presidential election."

Calhoun was too intelligent not to realize that a Southern rebellion could be successfully suppressed by a federal government supplied by Northern factories and a larger population. Yet he encouraged the defiance as a matter of principle. It is this cold rigidity that caused one Union officer to remark, as he surveyed the ruined Confederacy at the close of the Civil War, "the whole South is the grave of Calhoun."

HENRY CLAY

Born: 1777 Died: 1852

1824, 1832 & 1844

DEMOCRATIC-REPUBLICAN
NATIONAL REPUBLICAN
& WHIG

Defeated by:
JOHN QUINCY ADAMS,
ANDREW JACKSON,
& WILLIAM H. HARRISON

THE MASTER BUILDER

Why is it that when we glance over an impressive building, we murmur praise for the architects, but not for the contractors who managed the construction – those who drew up the contracts, hired laborers, selected the materials, and guided the project to completion despite a thousand unforeseen complications and delays?

Americans like to flatter themselves that the success of their great republic was a historical inevitability, foreordained from the signing of the Declaration of Independence in July 1776 (on the third – it was only announced on the fourth). However, there have been many promising republics that failed despite the efforts and convictions of their founders. The unique success of the United States owes as much to the sagacity and talent of those who led it in its early, uncertain decades as it does to those who first conceived and created it.

49

Among the master builders of the early republic, none stood taller than Henry Clay of Kentucky. Clay showed an early – and sustained – genius for the improvisation and compromise necessary to make a republic work. He helped the country survive its political infancy and enabled its difficult transition from a largely agrarian economy to the early industrial period, a shift which rocked and threatened to overthrow older, more established political orders in Europe. His work as the Speaker of the House of Representatives, and later as a senator, helped create an unwritten "user's manual" for the maintenance of a modern representative government.

He supported the War of 1812 as a signal to foreign powers that the United States was prepared to fight for its interests; later, he was a member of the diplomatic team that negotiated the Treaty of Ghent which ended that war. He promoted tariffs to help nascent American industries compete with a more advanced European manufacturing community. He took the role of Speaker of the House of Representatives and forged what had been a largely ceremonial role into a potent political force.

Like most able career politicians, Clay was a master of "responsible opportunism," a phrase applied to Abraham Lincoln, who, like many American politicians of succeeding generations, regarded Clay as the model of an ideal statesman. Clay never hid his ambitions, including the presidency, but rarely allowed them to follow courses more to his benefit than the country's.

One time he violated this rule was when he maneuvered the presidency to one of his rivals, John Quincy Adams, rather than to his stronger opponent, the charismatic Andrew Jackson. Jackson was regarded as the far more popular choice. By conspiring with Adams in exchange for a cabinet position, Clay was seen as thwarting the popular will to satiate his personal desire for greater power – and to achieve a step closer to the presidency. It was denounced as a "corrupt bargain" and damaged his reputation.

Clay's intrigues against Jackson seem to curse his presidential ambitions. In his future attempts to achieve the presidency, Clay was stymied by Jackson and other military men (William Henry Harrison, Zachary Taylor), whose martial exploits garnered more campaign support than Clay could muster for his legislative and diplomatic achievements.

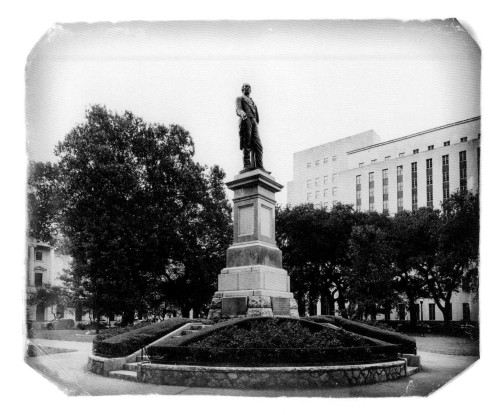

Henry Clay Monument, Lafayette Square | New Orleans, LA

Clay's opposition to annexing Texas lay in his prescient understanding of how Texas could upset the delicate equilibrium between slave and non-slave states, which Clay believed essential to maintain the Union's balance. His greatest legislative achievements lay in creating the political compromises necessary to provide sufficient time for the republic to become strong enough to resist and survive armed insurrection – a greater legacy than was left by most of the men who defeated him for president.

There are a number of memorials and monuments dedicated to Henry Clay. One of the more striking monuments can be found in New Orleans's Lafayette Square. Dating from 1860, the statue represents Clay in his prime with the palm of his right hand facing out as if addressing an audience, pleading his case. A metal fence encircles the monument, which lends a layer of accidental meaning, suggesting a man trapped within his own eloquence. It is a fitting reminder of a statesman who could convince his fellow Americans to do almost anything – except make him president.

DANIEL WEBSTER,
NEW ENGLAND CHOICE FOR
Twelfth President of the United States.

3⁄4

DANIEL WEBSTER

Born: 1782 Died: 1852

1836, 1840 & 1852
WHIG

Defeated by:
MARTIN VAN BUREN,
WILLIAM H. HARRISON,
& FRANKLIN PIERCE

THE ORATOR

They say you can hear his rolling voice in the hollows of the sky. And they say that if you go to his grave and speak loud and clear, "Dan'l Webster – Dan'l Webster!" the ground'll begin to shiver and the trees begin to shake.

You see, for a while, he was the biggest man in the country. He never got to be President, but he was the biggest man.

The Devil and Daniel Webster by Stephen Vincent Benet

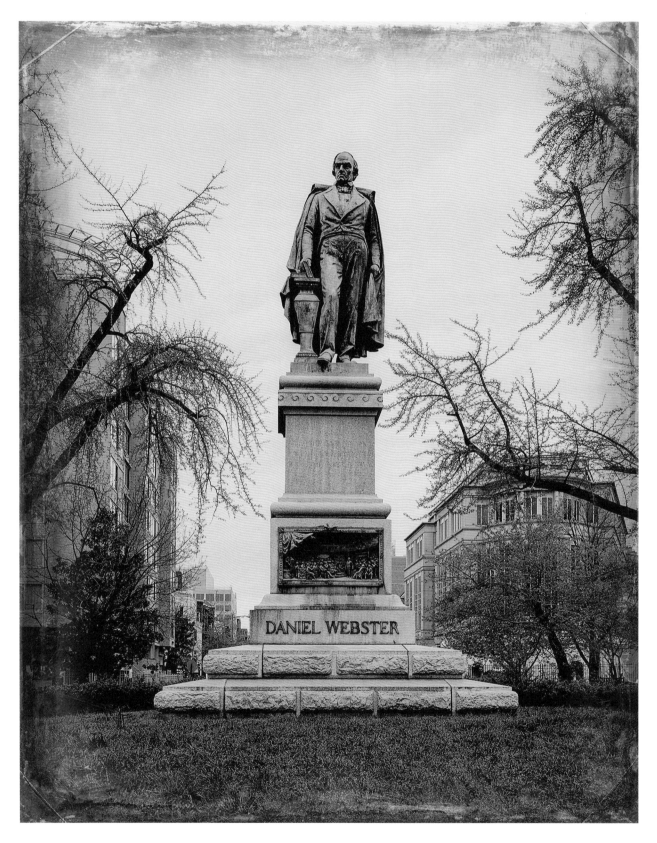

Daniel Webster's Memorial, Scott Circle | Washington, D.C.

DANIEL WEBSTER

Americans like large personalities, men as big and imposing as the country itself, embodiments of its restless energy, boundless self-confidence, and implacable will – singular figures whose lives are marked by a distinctive vitality that seems to channel the life force of the nation.

For every American titan who reaches the White House – an Andrew Jackson or a Theodore Roosevelt – there is another whose path to the highest office is blocked. Daniel Webster may be this group's supreme example.

Born in New Hampshire, he was educated at Phillips Exeter Academy and Dartmouth College. He began his professional life practicing law in a small town before moving to Portsmouth, where he could build a larger, more lucrative practice. Apart from an interest in the law, Webster inherited from his father, a judge, a devotion to the Federalist ideal placing national interests and unity above regional concerns and identity.

His first important foray into the political arena came in 1812, when he gave a speech before the Washington Benevolent Society, a political club for supporters of Federalism. The Embargo Act of 1807, enacted by the Jefferson administration to punish Great Britain and France for violating American neutrality, was severely impacting New England's economy, which relied heavily on trade with Europe. Disgruntled New Englanders were beginning to contemplate secession from the Union as a way to restore their regional economy. In this speech, Webster displayed the rhetorical skill for which he would eventually become famous. He voiced the grievances of New Englanders who felt that the federal government was interfering with their inalienable shipping rights. In the same speech, however, Webster was able to articulate a persuasive endorsement of national unity, even in the face of sacrifices undertaken for the good of the entire country.

The speech was reprinted, widely disseminated in New Hampshire, and sufficiently impressive to get Webster appointed to the Rockingham Convention, a committee to communicate New England's grievances to the federal government. One of Webster's most important contributions to the accompanying report was to stress the dangers of secession: "If a separation of the states shall ever take place, it will be, on some occasion, when one portion of the country undertakes to control, to regulate, and to sacrifice the interest of another."

Webster's increasing reputation led to his election in 1812 to the House of Representatives. He completed two terms, then returned to private practice as a lawyer to secure a better financial future for his family. With this plan in mind, he left Portsmouth for Boston to establish a new practice. He excelled thanks to his expertise in constitutional law; he would argue 223 cases before the Supreme Court presided over by John Marshall. He returned to the House of Representatives in 1822, this time as a member from Massachusetts. He continued to display rhetorical skill both inside and outside the government, such as giving the oration at the 50th anniversary of the Battle of Bunker Hill. In 1827, he achieved election to the Senate.

The Federalist Party from which Webster had sprung was too rigidly aristocratic to survive in a budding democracy. Unable to sustain popular support outside of the Northeast, the party faded away in the early 1820s. Many adherents, like Webster, shifted allegiance to the new Whig Party, which preserved the Federalists' conservative ideology while adopting a more inclusive approach toward the ordinary citizen.

Webster nonetheless maintained an unapologetically elitist perspective throughout his life. In his private practice, he was frequently counsel for the affluent merchants of New England. His association with the mercantile class was strengthened when, after his first wife died, he married Caroline LeRoy, the daughter of a prominent New York merchant. This association with the wealthier classes – and with New England in general – would prove an impediment to Webster's aspiration to the highest office.

Early in his career, Webster opposed tariffs as an obstacle to free trade. However, by the time he served in the Senate, he supported them as a way of protecting native industries and funding internal improvements. This was part of the "American System," a series of nationalistic policies promoted chiefly by Henry Clay of Kentucky, a fellow Whig and Webster's frequent ally.

Tariffs largely benefited the North, where industry was dominant. Clay was able to sell the idea to his Western constituents because, he argued, wealth earned in the North would be spent on Western agriculture. The Democrats, strongly represented in the South, opposed the tariffs given their extensive cotton trade

with other countries. In 1833, tensions over the tariffs led to South Carolina threatening to nullify federal law in their state. Conflict was narrowly averted by the creation of a compromise tariff. Nevertheless, the crisis had stirred secessionist talk in the South, encouraged by John C. Calhoun of South Carolina. Calhoun was the intellectual leader of the Southern politicians and the leading proponent of nullification theory – the idea that individual states could refuse to obey any federal law which the state deemed unconstitutional.

Prior to the Nullification Crisis of 1833, it had fallen to Webster to defend the position that American liberty was essentially bound to the Union. Robert Young Hayne, one of Calhoun's Southern allies in the Senate, hoped to drive a wedge between the North and the West in 1830 by accusing the North of limiting Western expansion. Webster responded to these accusations. The debate began to drift from its original topic until it touched upon the rights of states to nullify federal law. This led to Webster giving the speech known as the *Second Reply to Hayne*, perhaps his most famous oration. In the course of his speech, Webster uttered the phrase for which is best known: "Liberty and Union, now and forever, one and inseparable!"

Webster's stature and intellectual prowess gave defenders of national unity the articulate leader they needed to confront the formidable Calhoun and powerful Southern interests. This, combined with Henry Clay's gift for constructing compromises that gave the country time to grow, was of immeasurable aid to the United States in the years before the Civil War finally broke out.

Webster would go on to serve twice as Secretary of State, under John Tyler and Millard Fillmore. However, despite attempts to secure the nomination of the Whig Party for president in 1836, 1840 and 1852, he could never muster the necessary support. Like Calhoun and Clay, Webster was too distinctive a figure to achieve broad appeal. He died in 1852 at his home in Marshfield, Massachusetts.

Despite his failure to achieve the presidency, his impact on American history was acknowledged in 1957 when a Senate subcommittee selected him as one of the five greatest figures in Senate history. John F. Kennedy, in his book *Profiles in Courage*, noted that Webster had an "ability to make alive and supreme the latent sense of oneness, of union, that all Americans felt but few could express."

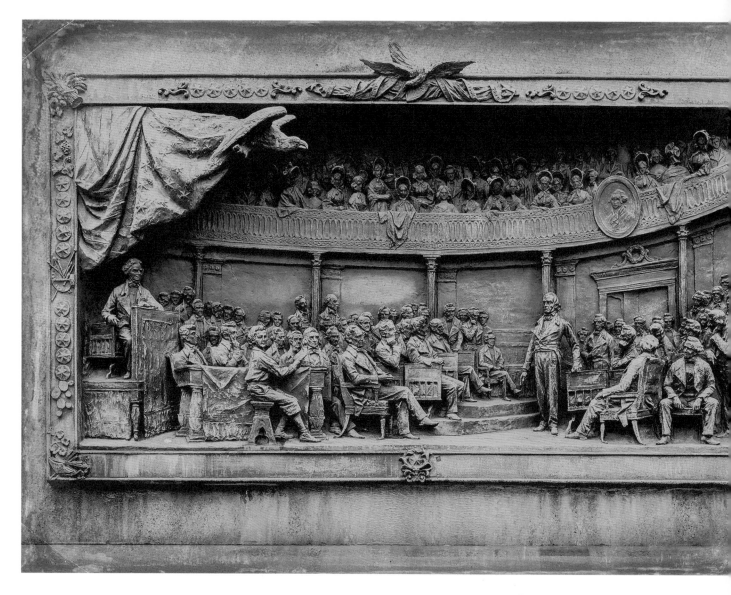

Detail on Daniel Webster's Memorial

There are numerous monuments to Webster: a college in New Hampshire, a special collections repository in the library at Dartmouth College, several schools, a state highway and a memorial figure in Washington, D.C., located not far from where he lived during his time in government service, all bear his name.

His most enduring monument, though, is literary. Published in the 1930s, Stephen Vincent Benet's short story "The Devil and Daniel Webster" is a beguiling yarn in which Webster, endowed with superhuman qualities, outmatches the devil in a court battle where a man's soul is at stake. The story presents Webster as a mythic figure, belonging to the American folktale pantheon alongside Paul Bunyan and Pecos Bill.

Perhaps the best way to bring Webster to life would be to read Benet's story out loud in front of his memorial in Washington, D.C. This monument, a forbidding bronze statue, conveys the aspects of Webster so vividly expressed in the Benet story:

"A man with a mouth like a mastiff, a brow like a mountain and eyes like burning anthracite – that was Dan'l Webster in his prime."

LEWIS CASS

Born: 1782 Died: 1866

1848
DEMOCRAT

Defeated by:
ZACHARY TAYLOR

THE PIONEER

Americans versed in both the history of politics and fashion in their country can be forgiven if they do a double take viewing the statue of Lewis Cass in the National Statuary Hall in Washington, D.C. The figure's girth and jowly cheeks capture Cass's appearance in the last years of his life, the antebellum period just prior to the Civil War. His double-breasted tailcoat, on the other hand, is of a sort that was in fashion decades earlier, in the first quarter of the nineteenth century when Cass began his career in politics.

The choice of clothing in a marble statue is too essential a detail for this to be mere oversight. More likely, the sculptor wished to convey the breadth of Cass's career as it extended from the promising, early years of the republic to the tumultuous age which brought forth the threat of disunion.

Cass, the son of a veteran of the Battle of Bunker Hill, was born in New Hampshire and educated at Phillips Exeter Academy, like many political notables. In 1800, his family moved west to Ohio, which gave him his first taste of the settler's life, a formative experience which would serve him well during the most crucial years of his public career. He began his work in public service as a US Marshal, a role he would give up to become a colonel in an Ohio regiment during the War of 1812. After the war, President Madison made Cass governor of the Michigan Territory, a position he would hold for the next eighteen years.

When people think of Detroit today, the images they are likely to associate with it – the automobile industry, Motown, urban decay – make it difficult to picture as anything but a faded industrial metropolis. In the early nineteenth century, however, it was the edge of the wilderness, *terra incognita*, the westernmost part of what was then the established regions of the United States. The challenges that settlers of the far west would encounter in the middle and last part of the century – undeveloped land, harsh climate, hostile natives – could all be encountered in the Michigan of the 1820s.

On top of these obstacles, Lewis Cass had another challenge, a particularly vexing problem the American pioneers of later generations did not have to face: the British Empire. The border between the United States and Canada, now the most peaceful region in the world, was in the nineteenth century a cause of tension and simmering conflict between the nascent American republic and Great Britain. This territorial rivalry resembled the Cold War, with two powers each determined to assert itself aggressively just short of resorting to open conflict. Michigan represented a particularly contentious region, given the presence of the Great Lakes and the value they offered as navigable trade routes. In his almost two decades in Detroit, Cass handled this thorny political issue deftly, while mapping the new territory, negotiating with native tribes, and convincing Americans from other parts of the country that Michigan was a good place to begin a new life.

His success in this role was the greatest triumph of his long years of public service and led to his first cabinet position as Secretary of War under Andrew Jackson. He followed this posting with an appointment as Minister to France. Given that his professional life had been spent mostly in pioneer settlements, his appointment

to Paris may have seemed unsuitable. However, Cass's skill as a diplomat, honed in meetings with Native American tribal leaders as well as his history of conflict with the British, made him an unusually effective minister and he served with distinction.

He returned to the United States and made his first run at the presidency in 1844, losing the nomination to James K. Polk. He then served as a senator from Michigan until 1848, when he finally achieved the Democratic nomination for president. He was defeated in the end not so much by his opponent Zachary Taylor as by his support for the controversial doctrine of popular sovereignty, which supported the position that voters in a territory should decide whether or not slavery would be legal once the territory achieved statehood. His intraparty rival, former president Martin Van Buren, used the issue to split the Democrats, many of whom shifting their support to the short-lived Free Soil Party, which nominated Van Buren as its candidate. Van Buren knew that he had no hope of winning, but was canny enough to understand that splitting the Democratic vote would block Cass's path to the presidency.

Cass's last role in politics was to serve as Secretary of State under James Buchanan. When Buchanan failed to actively oppose the secession of the Southern states with federal forces, Cass resigned in protest. He lived to see the end of the Civil War, dying in 1866.

Cass would have made a good president. Unlike Zachary Taylor, who was a good soldier but not a decisive leader, Lewis Cass had the temperament, experience, stamina, and thoughtfulness that have been hallmarks of our most able chief executives.

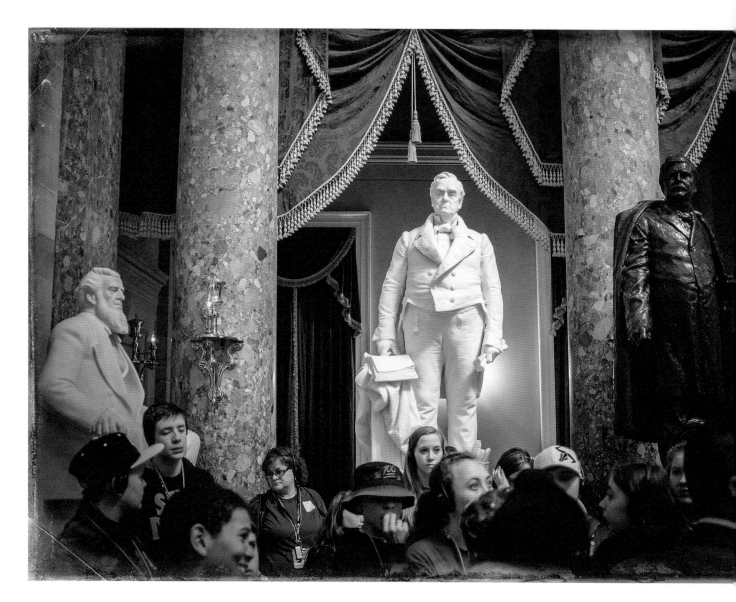

National Statuary Hall Collection | Washington, D.C.

Like his fellow Democrat and frontiersman Andrew Jackson, he understood that leadership was ultimately more about vigorous action than words, writing that:

"People may doubt what you say, but they will believe what you do."

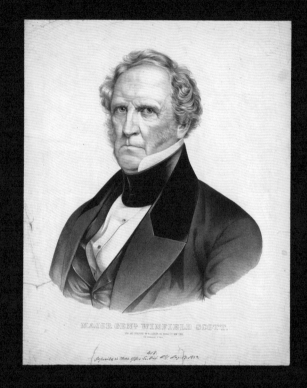

MAJOR GEN.ᴸ WINFIELD SCOTT.

WINFIELD SCOTT

Born: 1786 Died: 1866

1852
WHIG

Defeated by:
FRANKLIN PIERCE

THE LONG SOLDIER

"The finest specimen of manhood my eyes had ever beheld"

. . . was the opinion of young West Point cadet Ulysses S. Grant upon seeing Winfield Scott. Scott was to aspiring military men what Henry Clay was to many politicians – the exemplar and role model against which they measured themselves.

Winfield Scott served fifty-three years in the US Army, beginning when the American army was hardly formed. He understood that, despite the preference of many Americans for state militias, a young republic that hoped to span a continent needed a professional military. Apart from his outstanding work as a battlefield fighter – serving in every military campaign from the War of 1812 to the Civil War – the better part of his career was spent as one of the chief architects of the US Army.

Scott had intended a career in the law. However, his destiny was decided while he was in his native Virginia attending the trial of Aaron Burr, whose bitterness at having his path to the presidency blocked led to his involvement in schemes to have western lands secede from the United States. During Burr's trial, news of the British Navy attacking and boarding American vessels spurred Scott to join the Virginia militia. He was an imposing figure at 6'5" and, despite his youth, was soon placed in leadership positions.

Early missteps and failures – a one-year suspension for disregarding an order, becoming a British prisoner during the War of 1812 – did not slow his momentum. Released in a prisoner exchange, Scott returned to active duty and proved his military prowess by planning and executing a successful attack on British fortifications at Fort George, Ontario. He was promoted to colonel, and a year later to brigadier general. Scott became a general in 1814, at the age of 27, and would remain one for forty-seven years.

As part of his efforts to professionalize American forces, Scott visited Europe to study the more advanced and experienced forces there. Impressed by what he learned, he translated military manuals written by Napoleon into English. He went on to write and publish *Abstract of Infantry Tactics, Including Exercises and Manœuvres of Light-Infantry and Riflemen, for the Use of the Militia of the United States*, which remained a standard manual for the US Army for several years.

His life was not without controversy. He was involved in carrying out the expulsion of Cherokee Indians from their native lands to resettle them in Oklahoma, the infamous "Trail of Tears" in which thousands of Native Americans died. As the American population grew, the value of land along the East Coast increased. The fertile Cherokee lands in the South were too tempting for planters and settlers to resist. Scott was a humane man and attempted to carry out his unpleasant duty

with as much concern for the Cherokees as possible. His efforts were undermined by the lack of regular troops, which forced him to rely heavily on the Georgia militia, a less professional force and one populated by men eager to facilitate the Cherokee exodus.

Scott's greatest impact as a battlefield commander was in the war with Mexico. Many Americans are probably unaware that the United States ever went to war with Mexico (the Mexicans, assuredly, have not forgotten). Yet the Mexican-American War was one of the most consequential conflicts in our history. Without it, we would not have acquired the southwestern corner of today's United States: California, Nevada, and Utah, as well as territories that became part of Arizona, New Mexico, and Colorado. General (and future president) Zachary Taylor had led the initial operations against the Mexicans. Holding on to the conquered territories, however, would be difficult without a complete capitulation of the Mexican government. That required an attack on Mexico City. The logistical complexities of such an operation demanded the highest level of military competence – which for the government meant Winfield Scott.

Scott did not disappoint them. Following the route the Spanish conquistador Hernán Cortés blazed several centuries before, Scott began a series of battles starting at Vera Cruz on the Gulf Coast and fought his way inland, culminating in the Battle of Chapultepec, which resulted in the conquest of Mexico City. (This campaign, fought with considerable geographical and climate-related obstacles, so impressed the Duke of Wellington that he called Scott the "greatest living general.")

Having been crucial in winning the war, Scott proved equally adept at winning the peace. As military governor of occupied Mexico, he enforced a martial law that promised equal consequences for lawbreakers, whether they were Mexican or American. This even-handedness helped win the confidence of the Mexicans and helped facilitate the postwar transition.

Scott had been a contender for the Whig presidential nomination in 1840, but both he and Henry Clay – who was also maneuvering for the nomination – were passed over in favor of William Henry Harrison. Twelve years later, as the victor of Vera Cruz, Scott's national status meant there were few rivals in the Whig party who could have wrested the nomination from him. Paradoxically, his greatest success as

a soldier – the conquest of Mexico – sowed the seeds for his failure as a candidate. The sudden immense expansion of American territory upset the carefully calibrated balance between slave and non-slave states. The Compromise of 1850 help stave off the increasingly serious threat of disunion, but it also embittered and divided the Whigs. By 1852, internal divisions and animosity had all but wrecked the once-ascendant party. The Democratic candidate easily won the election, and the Whigs disbanded shortly thereafter, with their anti-slavery faction reforming under the banner of the Republican Party.

Scott stayed on in the army and was chief of staff when the final rupture took place between North and South. With Scott clearly too old to be the chief battlefield commander, the position was offered to his well-regarded subordinate, Colonel Robert E. Lee; Lee, of course, chose a different path. Command of the Union Army was then offered to and accepted by George McClellan, who had served under Scott in the Mexican-American War. McClellan, however, proceeded to treat Scott (along with President Abraham Lincoln) with disregard and condescension, and tensions between them rose through the following months.

Scott finally retired from the military in November 1861. It would take almost four long years for a man of comparable military skill, Ulysses S. Grant, to appear at the head of the Union Army. Grant's fighting spirit coupled with Scott's Anaconda Plan (finally adopted) broke the Southern Confederacy. Scott lived long enough to see the final victory, dying in 1866 at West Point where he had spent his final years.

His memorial, positioned in Scott Circle in Washington, D.C., is a classic equestrian statue – a bold, forceful rider atop a noble steed. Two things make it distinct. One, the horse appears to be engaged in a slow trot, as if taking a morning stroll. Two, Scott's right arm is akimbo. The overall effect is to project a man of confidence and capability at ease. The challenge, whatever it might be, will be met.

At the beginning of the rupture between the states, Robert E. Lee asked if he could remain in the US Army without going to war, unwilling to fight against his fellow Virginians. Scott replied that "I have no place in my army for equivocal men." Scott's

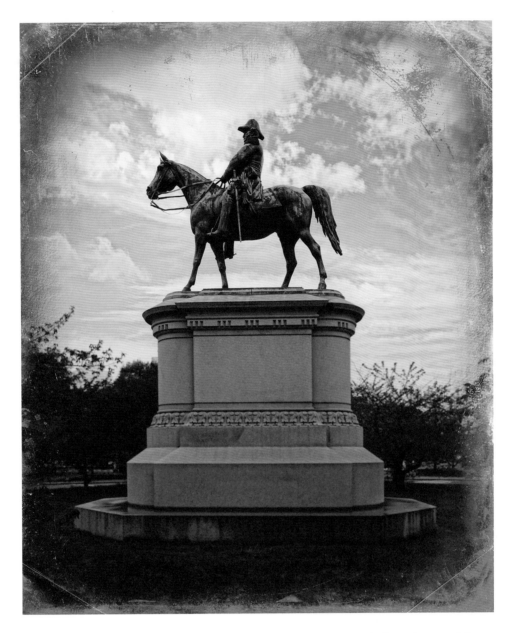

Winfield Scott's Memorial, Scott Circle | Washington, D.C.

rigid sternness may have at times made him a figure of fun to some ("old fuss and feathers"), but that steely determination was an essential ingredient in what made him formidable. In his character, he combined grit, self-discipline, and elan. If Manifest Destiny was the American secular faith, Scott was its living embodiment. Little wonder why so many people named their children after him; commanders on both sides of the Civil War bore his name.

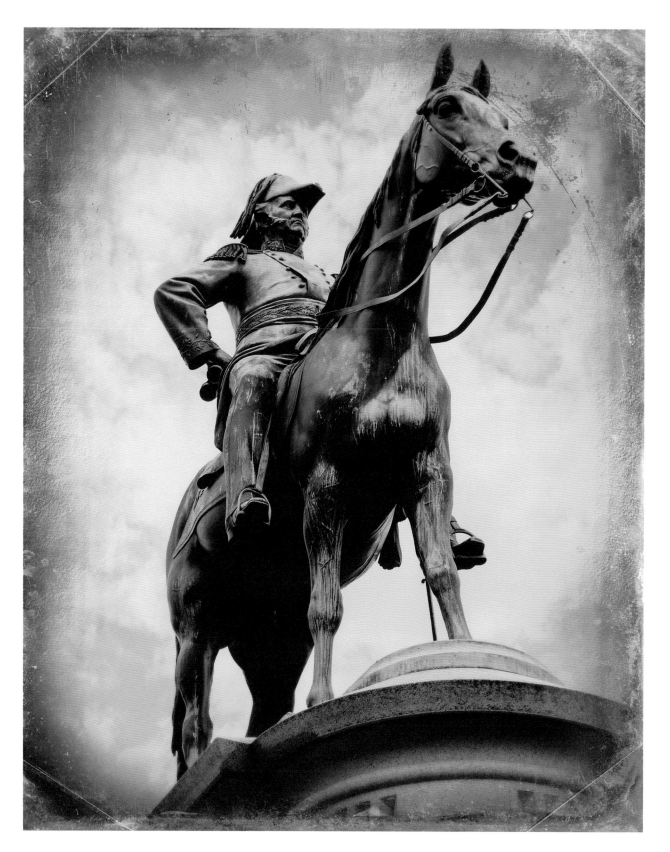

Detail of Winfield Scott's Memorial

Scott was a product of a time when Herman Melville wrote that Americans were:

" . . . the advance guard, sent on through the wilderness of untried things, to break a new path in the New World that is ours."

JNº C. FREMONT. Wº L. DAYTON.
THE CHAMPIONS OF FREEDOM.

JOHN C. FRÉMONT

Born: 1813 Died: 1890

1856
REPUBLICAN

Defeated by:
JAMES BUCHANAN

THE PATHFINDER

It is difficult to travel widely in the United States without encountering the name Fremont. There is a Fremont County in Colorado, Idaho, Iowa, and Wyoming. There are Fremont Peaks in several states, stretching from California to Maine. There is a Fremont Canyon and a Fremont River. There is a mountain range called Fremont Pass in Colorado. Over twenty varieties of plants native to America bear his name, such as *Populus fremontii*. There are cities named Fremont in California, Nebraska, Michigan and Ohio, as well as towns and villages across the country. His name adorns streets, a highway, and a bridge. Few individuals have planted their name as firmly on the American landscape as John Charles Frémont – which makes his status as a forgotten figure all the more poignant.

Frémont was born the product of an affair between an Army officer's wife and a French Canadian who had escaped imprisonment by the British in Quebec. The officer cast out his wife and sought to divorce her, though it is not altogether clear whether a divorce was ever issued. Thus, when Frémont was born in 1813 in Savannah, he was considered illegitimate. His father died before the boy's fifth birthday, leaving his mother to care for him and his siblings. He inherited his father's charm, good looks, and pluck. Moreover, he had an aptitude for attracting influential patrons who could help him, an important trait in decades to come when he experienced reversals of fortune.

He attended the College of Charleston long enough to acquire important knowledge about math and natural sciences which would be invaluable in his future career. As a consequence of pursuing a love affair rather than his studies, he was expelled from college. However, the education he had received qualified him for a post as a mathematics instructor on the naval vessel USS *Natchez*. This was followed by an appointment as a second lieutenant in the US Army Corps of Topographical Engineers, which allowed him to gain extensive experience surveying territory in the Midwest, particularly under the tutelage of Joseph Nicollet, a gifted French geographer.

Despite his humble origins, Frémont was, throughout his life, the beneficiary of a number of strokes of good fortune. One of these was winning the heart of Jessie Benton, the daughter of Senator Thomas Hart Benton of Missouri. Benton was powerful and imperious; he once fought a duel with Andrew Jackson, who he nonetheless came to regard as a good friend. He could not have been pleased that his daughter – one of the most eligible young women in the United States – had settled her heart on a penniless officer of dubious birth. Yet he relented and came to accept the marriage, a decision that would prove beneficial to both men.

Senator Benton was one of the leading exponents of the doctrine of Manifest Destiny, the belief that the United States was fated to extend its territory across the entire continent. He used his considerable influence to secure Frémont an appointment as leader of one of the survey teams which would map and explore the Western Territories acquired by the United States through the Louisiana Purchase.

Starting in the 1840s and extending into the early 1850s, Frémont led five

expeditions into the Western Territories. Along with companions such as the mountain man Kit Carson, he surveyed and created detailed maps and descriptions of the regions open to American settlement, stretching from the Missouri River to the California coast. After his first expedition, he wrote newspaper articles and a book about what he had seen. These publications turned him into a celebrity, the best-known explorer since Lewis and Clark. They also played a crucial role in firing up the public imagination about the possibilities of settling the West – the Mormons, for example, were inspired by Frémont's description of the Utah Territory.

Frémont had setbacks along the way. A dispute with an Army general about which of them had been appointed military governor of California resulted in the headstrong Frémont being sent back to Washington, D.C., for a court-martial on the charge of insubordination. Although Frémont was convicted, President Polk offered him a pardon so he could return to active duty in the Army. Frémont, regarding acceptance as an admission of guilt, refused the pardon and resigned his commission. He would pursue two more expeditions as a civilian before settling down on property he had purchased in California. In one of those twists of fate which forever followed Frémont, gold was discovered on his California property, making him a millionaire.

By the 1850s, Frémont personified for many people the new American – the Western man, whose vision and derring-do symbolized the enormous potential of the growing country. In 1850, he made his first venture into politics by successfully running as a Free Soil Democrat in California's first senatorial race. Little wonder then that in 1856 he was approached by both the Democratic Party and the newly formed Republican Party with offers to serve as their presidential candidate. Frémont and his wife Jessie were both firm abolitionists, so the Democratic Party platform, which supported slavery, was unacceptable. Frémont accepted the Republican nomination, and the Democratic nomination went to James Buchanan.

The Republicans, while they gathered many of the best men from the defunct Whig Party, were too new a political organization to effectively challenge the well-built Democratic Party machine. Also, the Republicans had no interest in trying to maintain the delicate balance between the country's anti- and pro-slavery factions.

Fremont Pass, Rocky Mountains | Colorado

They made their position clear with the campaign slogan "Free Soil, Free Labor, Free Speech, Free Men, and Frémont!"

The country was not yet ready for the civil strife that would inevitably follow the election of a confirmed opponent of slavery. The outcome of the election of 1856 was not as surprising as the Republicans' strong showing in their first presidential election. Far from being discouraged, they were emboldened. Frémont took his loss with equanimity.

When war finally arrived after the election of Abraham Lincoln, Frémont was brought back into the Army as a major general and made military commander of Missouri, a state which tentatively remained loyal to the Union but had a significant slaveholding community. Managing this delicate balancing act required a firm but diplomatic nature. Frémont had the first quality, but lacked the second. This was clearly demonstrated when he issued the Frémont Proclamation, which declared martial law in Missouri and announced that anyone found taking arms against the Union would be court-martialed and shot. Moreover, if they owned slaves, the slaves would be immediately set free.

Frémont justified his edict as a necessity of war in a state of uncertain loyalties. However, it created tumult in other parts of the country. While abolitionists cheered Frémont's measure, others were aghast at an action which had clear political ramifications beyond Missouri.

One of the people vexed was Abraham Lincoln, who firmly believed that military governors should restrict themselves to maintaining order in their regions and not attempt to formulate policies aimed at altering the political environment. Lincoln sent a letter to Frémont asking him to rescind the emancipation portion of his edict. Frémont refused, instead sending his wife Jessie to the White House to plead his case.

Lincoln, legitimately aggrieved at Frémont's lack of cooperation, ordered him to make the changes. Shortly thereafter, he removed Frémont from his command under the pretext that Frémont's administration in Missouri was incompetent. For awhile, Frémont had an independent command until it was folded into the Union Army under the command of General John Pope. Frémont, again the

contrarian, refused to serve under an officer he regarded as junior to himself. He resigned his commission and moved with his family to New York.

After the war, investments Frémont had made failed badly, undermining his financial situation. Apart from a brief tenure as territorial governor of Arizona, he never again held a significant position and his family was forced to rely on income earned from his wife Jessie's writings. He died in New York City in 1890 at the age of 77.

Frémont, like his contemporary George McClellan, could never match the brilliant blaze of his early career and was doomed to live out decades in the shadow of his younger self. The difference between them lay in that while McClellan never fulfilled his early potential, Frémont did – only it was in his role as explorer, not as a politician or military commander. Though he was an inept administrator during the Civil War, he made one sterling contribution to that conflict – recognizing the ability of an overlooked officer named Ulysses S. Grant, and promoting him to a key post early in the war. His proclamation debacle also had a positive effect in the end, by forcing Abraham Lincoln to think harder about the appropriate steps necessary to create a national Emancipation Proclamation.

Even in failure, John Charles Frémont blazed a path for others.

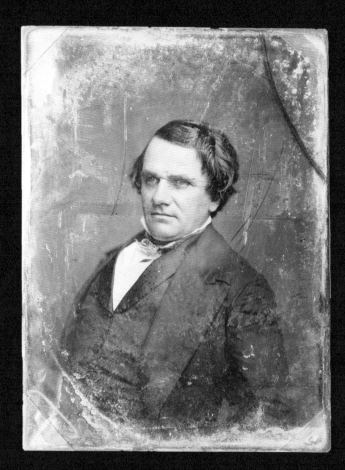

STEPHEN DOUGLAS
Born: 1813 Died: 1861

1860
DEMOCRAT

Defeated by:
ABRAHAM LINCOLN

MIDWIFE TO ANOTHER MAN'S GLORY

The purpose of any public monument is twofold. It is an *aide-mémoire*, intended to remind us of political and civic leaders whose lives had impact, who influenced the flow of events, who made a difference in the world. But a monument is also intended to shape the memory it invokes, instructing viewers how the subject should be remembered.

The first thing you notice about Stephen Douglas's memorial statue is how much pedestal it takes to make him stand tall. It's unlikely that the admirers of Douglas who erected the monument deliberately planned that perception. However, a monument is like a text; those who encounter it may see meanings that were never intended by the author.

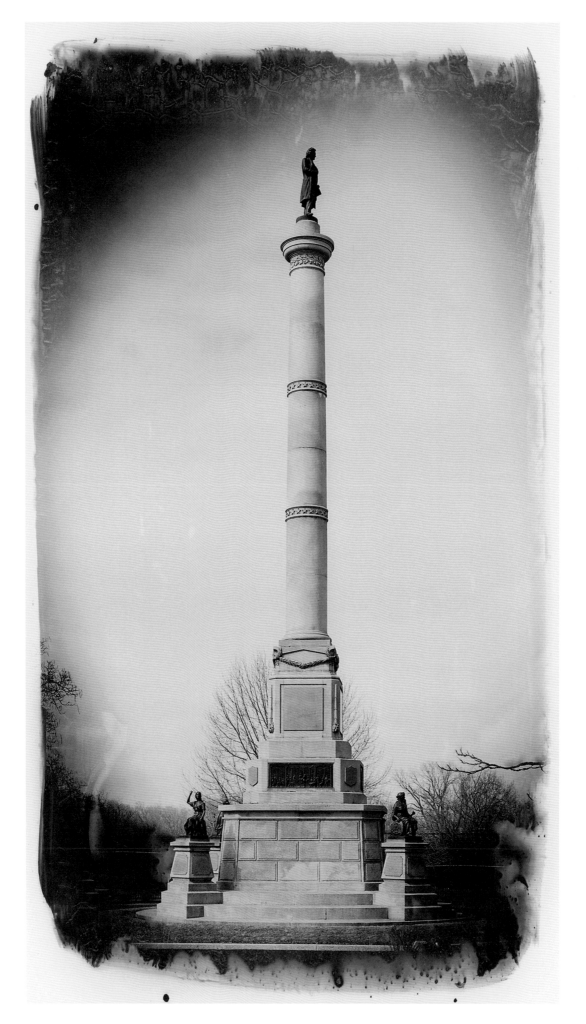

Stephen Douglas Tomb | Chicago, IL

STEPHEN DOUGLAS

Douglas was called a "little giant" in his lifetime. Originally, the moniker was intended to draw flattering attention to the contrast between his small stature and his outsized ability. However, the phrase can also express a poignant incompleteness; a "little giant" is a creature that has failed to achieve its natural potentiality. The pedestal at his monument is far larger than his statue, unintentionally highlighting the props necessary to raise Douglas to the heights he failed to achieve on his own.

Among the men who would be president, there is a type that appears repeatedly: the inspirational schemer, both a genuine leader and an unremitting opportunist. Douglas was the quintessential inspirational schemer. He wanted what was best for his country, but his rampant ambition and self-promotion overwhelmed both his moral judgment and his strategic sense.

The issue of extending slavery into new territories was a sleeping tiger, lulled by legislative compromises devised by men like Douglas and his idol, Henry Clay. Douglas, full of hubris, thought that it could be permanently tamed by his concept of "popular sovereignty," the idea that local voters – not Congress or the Supreme Court – should decide whether slavery would be legal in a new territory. Thus controlled, Douglas could put a leash on the slavery extension issue and let it lead him to the doors of the White House.

The resulting Kansas-Nebraska Act was one of the greatest acts of political miscalculation in American history. Far from settling the slavery issue, it led to armed conflict in the Midwest. The tumult destroyed the Whig Party, which was rapidly replaced by an ardently anti-slavery Republican Party – whose existence further splintered and radicalized the Southern-leaning Democratic Party.

Despite this enormous self-inflicted wound to his career, which cost him the Democratic presidential nomination in 1856, Douglas was popular enough to largely ignore the almost unknown candidate Republicans ran against him in the 1858 senatorial contest in Illinois. But he knew and respected Abraham Lincoln. Douglas also wanted voters to know that he was willing to debate his ideas in a public forum. He understood the favor he was doing Lincoln – and he did it anyway. While Douglas won re-election, their series of debates made Lincoln famous, one of the rising stars of the Republican Party.

The best side of Douglas's nature made Lincoln possible; the worst side of Douglas made Lincoln necessary. It is due to his special association with Lincoln that Douglas has more name recognition than almost any other unsuccessful presidential candidate. He was, in the end, the midwife to another man's glory.

Douglas died young. As a politician, he was a spent force; as a man in his forties, he was still a work in progress. Before his death, he made a point of working with Lincoln's administration to support the Union and fight secession. Had he lived longer, his efforts and talents might have restored some measure of his influence. Older, sadder, and wiser, a post-Civil War Douglas might have helped bind the wounds of the war that his political opportunism helped create.

Douglas helped Lincoln become immortal and Lincoln, ever charitable, gave a small portion of lasting fame to his most capable political rival.

Consider the difference between the monuments dedicated to preserving the two men's memories. In Lincoln's memorial, the late president literally achieves the full physical status of a giant. He is seated, a man at rest, his great work complete. By contrast, Douglas's memorial presents him at his diminutive human scale, dependent on a platform to achieve elevation.

He is simply standing and looking, as if searching for greatness that might have been his.

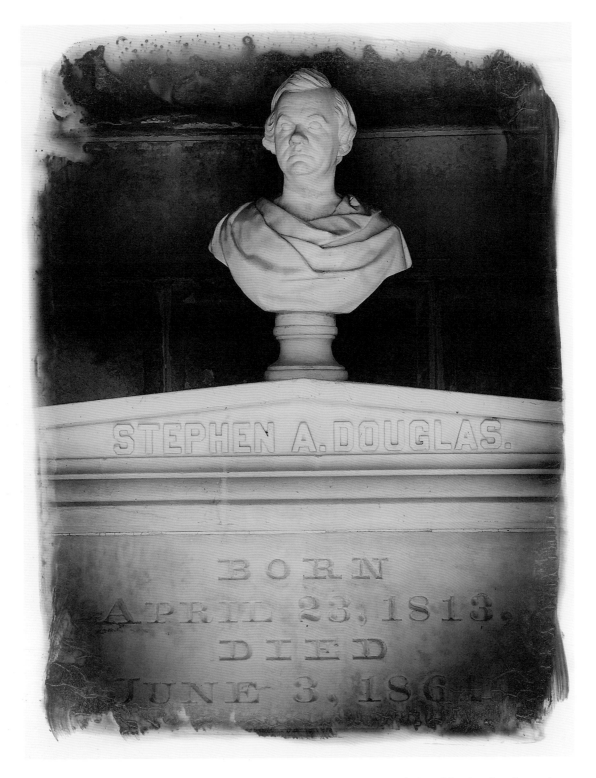

Detail view of Stephen Douglas tomb

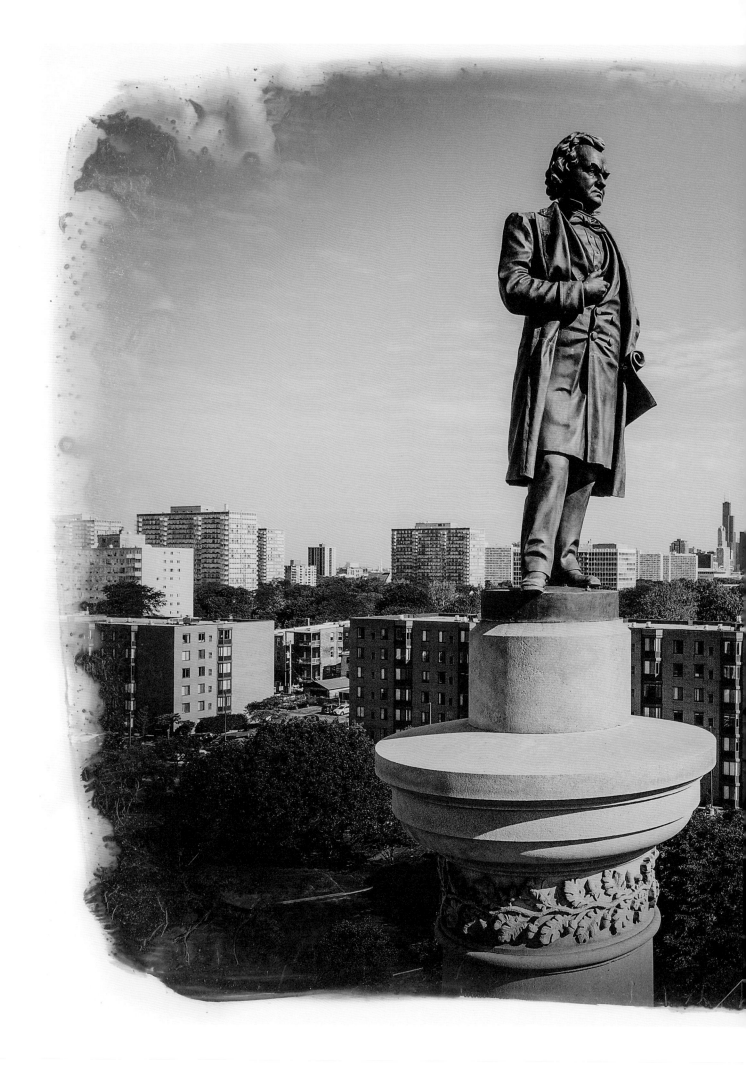

Detail view of Stephen Douglas statue

GEORGE McCLELLAN

Born: 1826 Died: 1885

1864
DEMOCRAT

Defeated by:
ABRAHAM LINCOLN

THE ORGANIZER

The British literary critic Cyril Connolly once observed that, "Whom the gods would destroy, they first call promising."

Few figures in American history emerged on the world stage surrounded by as much hope and anticipation as George McClellan. McClellan was one of the most professionally capable figures ever to run for president. During his career, he distinguished himself in both public and private spheres. His is the peculiar tragedy of being successful at almost every task he was given – except the most important one.

A graduate of West Point and the son of a prominent surgeon, McClellan saw combat during the Mexican-American War, where he impressed his colleagues and superiors as a capable man of great promise. After the war, McClellan served as a civil engineer, explorer, and surveyor. In the 1850s he undertook several missions for then-Secretary of War Jefferson Davis, many involving surveys for the proposed transcontinental railroad. The building of a transcontinental railroad was one of the first great national projects – the moonshot of its day. That McClellan was appointed to several projects attached to its development indicates how highly people in positions of power and influence thought of him.

After a tour as an American military observer of the Crimean War, McClellan leveraged his experience with railroads and left the military for a senior management position in the railroad industry, first as vice president of the Illinois Central Railroad and then as president of the Ohio and Mississippi Railroad. Given his experience and formidable professional network, with high-placed contacts in the military, government, and private sectors, it made perfect sense that the government would turn to McClellan to restore the confidence of a nation suddenly riven by civil war. Even McClellan's physical stature (5'8") was seen as something in his favor, encouraging comparisons to Napoleon. (His nickname from his West Point days was "Little Mac.")

As a Democrat, he provided an important element in a wartime coalition that needed a balance of Republicans and Democrats to emphasize national unity. Appointed a major general at the age of 34, he was outranked only by Winfield Scott, an old friend of his father. He set his considerable organizational abilities to the enormous task of taking thousands of raw recruits and turning them into professional soldiers. This would represent his greatest achievement: the creation of what would become the Army of the Potomac, the main Union army, the fighting force that would destroy the Southern Confederacy.

The great tasks history placed on his shoulders seem to be challenges he had been preparing for his whole life. However, cracks began to appear in his picture-perfect facade. Having risen far and fast while still relatively young, McClellan displayed considerable arrogance, which made him prickly and difficult while working with his military and political superiors. He clashed with Scott over the

grand strategy for executing the war (Scott's Anaconda Plan would in time prove to be the successful approach to defeating the South). After he replaced Scott as the supreme Union commander, he turned his disdain upon Abraham Lincoln, making disparaging remarks in private, referring to Lincoln as "nothing more than a well-meaning baboon." He even ignored the president when the latter came to visit McClellan at his house; McClellan refused to see him and went to bed, though Lincoln had been waiting quietly in McClellan's study for an audience. Lincoln took McClellan's disrespect in stride, saying, "All I want out of General McClellan is a victory, and if to hold his horse will bring it, I will gladly hold his horse."

For all his considerable ability at forging the Union Army, he lacked similar skill for leading it. When battle approached, McClellan became tentative. He would call for more troops, more preparations. The civil engineer in him, preferring order and precise detail, could not embrace the chaos and uncertainty that battle requires. He had created a great weapon, but lacked the qualities to wield it effectively. He had no major victories except Antietam – in which he had the benefit of discovering Robert E. Lee's plans before the battle.

Although his concern for his men endeared him to his troops, this inertia eroded the North's faith in him as a battlefield commander. One wit remarked that while McClellan had the impressive appearance of a Greek statue, he also had the energy of one. Frustrated by his general's lack of initiative, Lincoln removed McClellan as head of the Army (bringing him back later for another chance, in which McClellan again failed to make needed military progress).

The Democrats, capitalizing on McClellan's still-potent popularity, nominated him as their candidate in 1864. He may well have triumphed over Lincoln had it not been for a party platform created by the appeasement faction of the Democratic Party, which called for a negotiated end to the war rather than the continued pursuit of victory. With defeat of the Confederacy within sight, voters in the North could not accept this; even McClellan himself was privately opposed to this position, but supported it out of party loyalty. He was defeated, largely owing to the votes of the soldiers in the army he had created.

His postwar years were comfortable, if largely uneventful. He and his family traveled in Europe; his son Max was born in Germany. McClellan continued to

alternate between private and public sector jobs, even spending a few years as governor of New Jersey. He died suddenly of a heart attack at age 58 in 1885 in Trenton.

McClellan's reputation suffered in the decades after his death. While Lincoln's status grew in the public mind, McClellan's disdain for his great commander-in-chief became public knowledge with the posthumous publication of his private papers. His lack of respect for Lincoln, combined with his failure to lead the North to an early victory, condemned him to be regarded as what historian and cultural critic Garry Wills has called an "antitype" leader – the opposite of what a truly positive, effective leader should be.

Yet McClellan's equestrian memorial on Washington's Connecticut Avenue, created in 1907, suggests that his contemporaries, in their reflective years, had reason to think more highly of him than history scholars analyzing him from a distance. Perhaps the best – and kindest – appraisal of McClellan came from Ulysses S. Grant, the man who would earn both the military glory and the presidency denied to McClellan. In his memoirs, Grant wrote:

"McClellan is to me one of the mysteries of the war . . . but the test which was applied to him would be terrible to any man, being made a major-general at the beginning of the war. It has always seemed to me that the critics of McClellan do not consider this vast and cruel responsibility – the war, a new thing to all of us, the army new, everything to do from the outset, with a restless people and Congress. McClellan was a young man when this devolved upon him, and if he did not succeed, it was because the conditions of success were so trying. If McClellan had gone into the war as Sherman, Thomas, or Meade, had fought his way along and up, I have no reason to suppose that he would not have won as high a distinction as any of us."

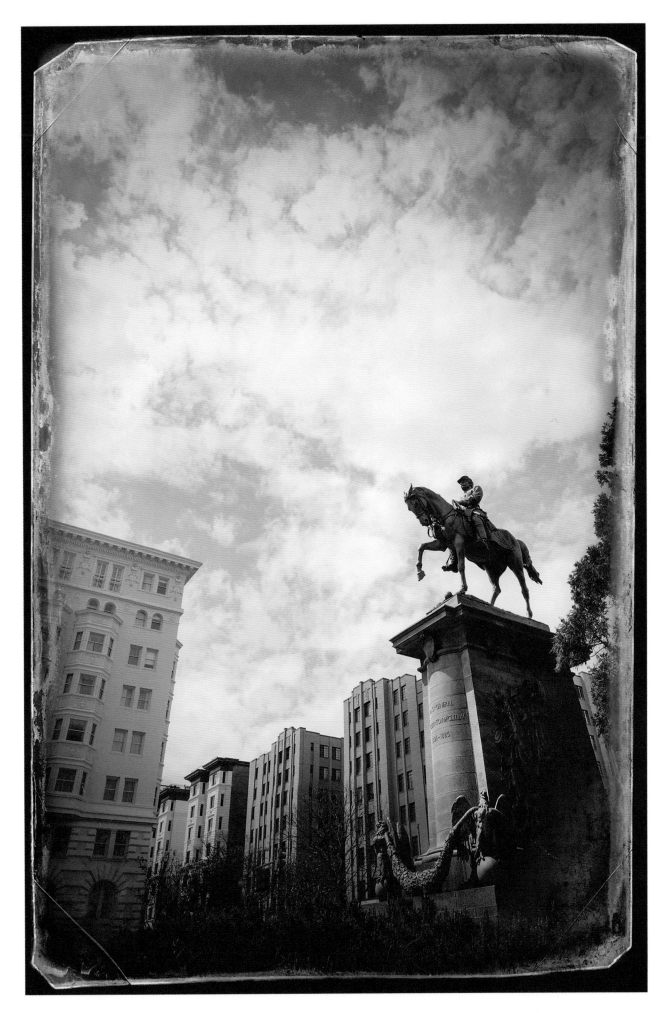

Major General George B. McClellan Memorial | Washington, D.C.

HORATIO SEYMOUR

Born: 1810 Died: 1886

1868
DEMOCRAT

Defeated by:
ULYSSES S. GRANT

THE RELUCTANT CANDIDATE

There are few greater disadvantages in politics than running against a war hero. It is a particularly arduous task if your challenger is the master general who saved the country from disunion. Chosen as candidate for the Democratic Party just three years after the end of the Civil War, Horatio Seymour had the awful misfortune of standing against Ulysses S. Grant, the man whose military prowess helped save the United States. Seymour never really had a chance. The only consolation was that he did not really want one.

Seymour, who had served several terms as the governor of New York, did not seek the 1868 Democratic nomination. His party was at a low point, still recovering from having many of its most prominent members join the Confederacy. After twenty-two ballots, there was still no candidate selected, so Seymour, the chairman of the convention, was pressed into service. As he no doubt expected, he suffered a staggering loss to Grant, with 80 electoral votes to Grant's 214.

Despite this defeat, Seymour's party continued in the following years to offer him opportunities at high office. These included the chance to enter the Senate, another term as New York's governor, and even another attempt at the presidential nomination in 1880. Gifted and capable, Seymour was a quiet man who preferred to influence and advise the Democratic Party rather than seek another high office. He died in 1886.

The quality of a memorial can betray the ambivalent feelings a community has towards a once-prominent figure. In Pompey, New York, Seymour's birthplace, there is a plaque commemorating his connection to the town. The plaque is bland and indistinctive, save for one detail: the year of his birth, which is incorrectly listed as 1811, not 1810. The William G. Pomeroy Foundation, which sponsored the plaque, acknowledges the error on its website but does not appear sufficiently troubled by the mistake to alter the sign. Seymour's contemporary General Sherman once dryly defined military fame as "to be killed on the field of battle and have your name misspelled in the newspapers." Something similar might be said about the ephemeral nature of political fame.

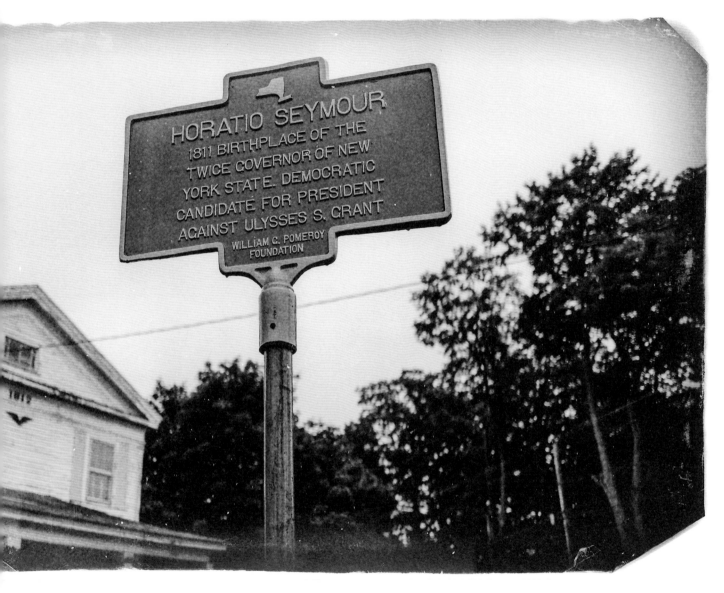

Historical marker, Sweet Road, Pompey Hill | Pompey, NY

H. GREELEY G. BROWN

THE PEOPLES' CHOICE,

HORACE GREELEY

Born: 1811 Died: 1872

1872

LIBERAL REPUBLICAN / DEMOCRAT

Defeated by:

ULYSSES S. GRANT

REBEL WITH A CAUSE

What does it say about cultural memory in America that we often recollect trivial details about the lives of public men while forgetting the substance of their achievements? We remember Thomas Dewey because of a newspaper error ("Dewey Defeats Truman"), William Jennings Bryan because of the Scopes Trial, and Horace Greeley because he pointed out to the young men among his many readers that there was more opportunity awaiting them in the developing West than in the settled East:

"Go West, young man."

Born into an impoverished family in New Hampshire, Greeley could trace his ancestry to settlers from England. His intellectual precocity was recognized early; neighbors offered to raise the funds to send him to the prestigious Phillips Exeter Academy, though his poor but proud family declined. He followed the advice he would give to others decades later by heading west, first into Vermont to work as a printer's apprentice, and then to New York.

New York City, the financial capital of the new nation, never lacked for hungry young men on the make, especially if they were interested in journalism and politics – Greeley's lifelong passions. His early years as a journalist were spent moving from publication to publication. His first job as a newspaper editor was at the *New York Morning Post*. When that effort did not succeed, he moved to other publications such as the *Constitutionalist* and the *New-Yorker* (a different publication from the current one of that name). In 1841 he founded the *New York Tribune*, which would become a powerful vehicle for his talents as an editor and writer, and for the large stable of journalistic talent he would attract (including Karl Marx, who wrote articles for the *Tribune* on European politics).

He also lent his energy and abilities to the Whig Party, forerunner of the Republican Party, by publishing their campaign literature and writing lyrics for campaign songs. His talent and efforts brought him to the attention of Thurlow Weed, an Albany publisher and Whig Party stalwart, and William Seward, a rising party star. The three formed an informal triumvirate to advance their shared interests. The more socially adept Weed and Seward, however, regarded the frequently awkward Greeley with condescension, never taking seriously his aspirations for political office (the only time Greeley served in office was three months as a member of the House of Representatives).

This lack of respect grated on Greeley, especially after he spent years helping promote Seward's political career. Greeley finally broke with Weed and Seward in 1860 when he supported Edward Bates – one of Seward's rivals – for the Republican nomination. He then helped maneuver Abraham Lincoln of Illinois into position as a compromise candidate, effectively taking his revenge on a stunned Weed and Seward.

Despite competition from the *New York Times* – founded by Greeley's former

assistant – the *New York Tribune* became the most important American newspaper with a national distribution. Greeley's vision of aggressive national expansion balanced with attention to the needs of working people won him a vast following, especially in the emerging Midwest. His articles clearly demonstrated that he thought long and deeply about the needs of the evolving national community. In clear, forceful prose that anyone could understand, Greeley articulated national problems and offered viable solutions that considered all its aspects: social, economic, geographical, and political.

Despite his great talents, many of his contemporaries in the establishment held him at arm's length. While he understood problems, he did not always understand people. He could be assertive to the point of being tactless and erratic in his views. When the Southern states first moved towards secession, he advocated letting them go peaceably. When they fired on Fort Sumter, however, he banged the loudest drums for war, using the *Tribune* to pressure Lincoln into aggressive early action ("Onward towards Richmond") before the Union Army was fully prepared, resulting in the disastrous first Battle of Bull Run. While Greeley was an early and determined advocate of abolishing slavery, he also tried to bring about a negotiated peace with the South. After the war, he enraged many of his readers by helping pay the bond for Jefferson Davis, thinking this act of magnanimity would help heal the bitter feelings of war.

By 1872 it had become clear that Ulysses Grant, for all his military competence, was an inept administrator-in-chief. Corruption was rampant in a Republican Party drunk on the near-monopoly of power it enjoyed in the post-Civil War years. Greeley, disappointed with Grant, joined with other disillusioned Republicans to break off and form their own Liberal Republican Party. Their rebellion was intended to combat the corrosive effects of continuing military governments in the South that served no other purpose than to enrich corrupt bureaucrats and extend the power of the Republican Party. The Democrats, lacking a viable challenger to Grant, joined with the Liberal Republicans to nominate Greeley.

Given Grant's continuing aura as the savior of the Union, any challenge was quixotic. Predictably, Greeley lost overwhelmingly. By opposing Grant, however, Greeley helped set a precedent: challenges to a sitting president need not be restricted

solely to the opposition party. Theodore Roosevelt would follow Greeley's example by forming the Bull Moose Party in 1912 to challenge the Republican establishment supporting President Taft.

Even if he had by some miracle won, Greeley may not have survived to serve as president. His health broke in November 1872, and he died before the electoral votes were cast. Despite news of his declining health, Greeley's sudden death was a shock to the nation. His critics fell silent, and the country was left to realize what a singular figure they had lost. Even Grant was among the mourners at Greeley's funeral.

Greeley's statue in New York's City Hall Park, not far from where his offices once stood, shows him in repose holding what appears to be a printer's proof of newspaper copy. With his bald head, side hair and serious expression, a visitor could mistake him for Benjamin Franklin's somber younger brother. The overall effect is consistent with the stony gravitas conveyed by so many nineteenth-century monuments. While well-intentioned, it fails to capture Greeley's idiosyncratic character. It does not, for example, include the spectacles that were omnipresent on his face throughout his adult life and which, along with his unfashionably long hair in the back of his head and chin beard, gave him a vaguely bohemian look.

Greeley's greatness lay in the way his personality combined three distinctly American archetypes. The first is the old Yankee: industrious, honest, and democratic. The second is the investigative journalist, relentlessly determined to hold the powerful accountable to the people. The third is the geek savant – awkwardness combined with a monomaniacal focus on achieving a goal, heedless of how his disregard for social norms may upset others.

Journalistic prose was his computer code. The operating system he sought to program was the American consciousness.

HORACE GREELEY

Horace Greeley Monument, City Hall Park | New York, NY

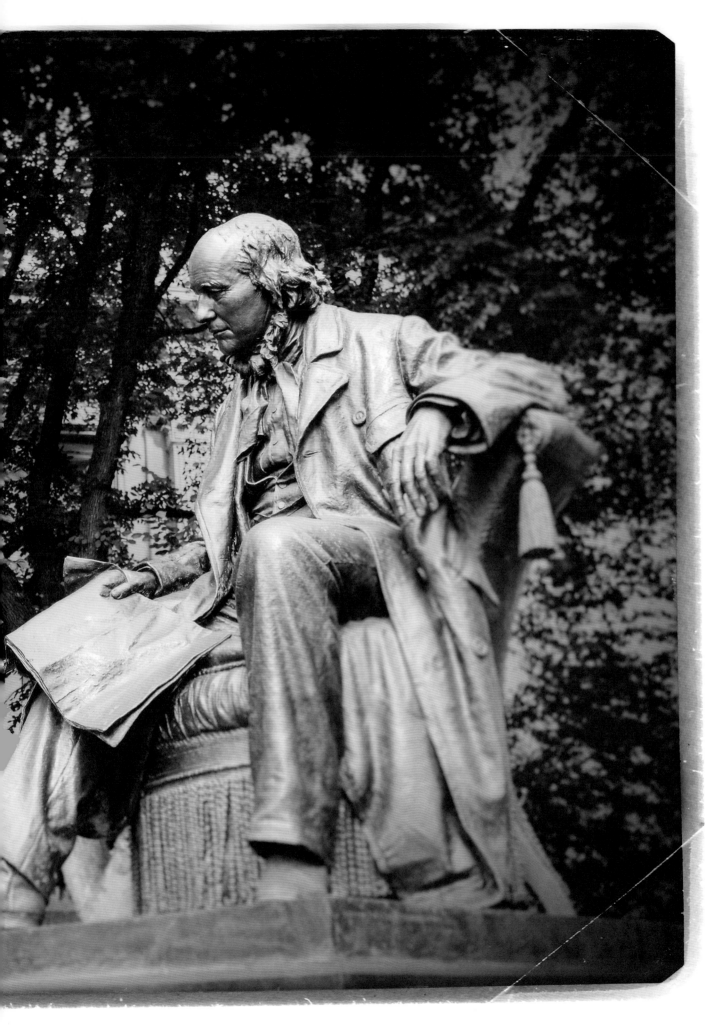

Detail of Horace Greeley Monument

SAMUEL TILDEN

Born: 1814 Died: 1886

1876
DEMOCRAT

Defeated by:
RUTHERFORD B. HAYES

THE GOOD LOSER

Democrat Samuel Tilden is an anomaly among the men who might have become president. Other failed aspirants had to bear the pain of failing to secure the necessary votes. Tilden won the popular votes needed to achieve the presidency. However the Republican opposition, having controlled the presidency since the beginning of the Civil War, was not yet prepared to relinquish power and challenged the election outcome. The ensuing political struggle might have torn open the wounds from the war and led to a breakdown in the still-fragile body politic.

A more traditional candidate might have taken up the fight, convinced that pugnacity was what the moment required. But Tilden – calm, diffident, and cerebral – assessed the situation with clinical serenity and did what few men were capable of. He walked away.

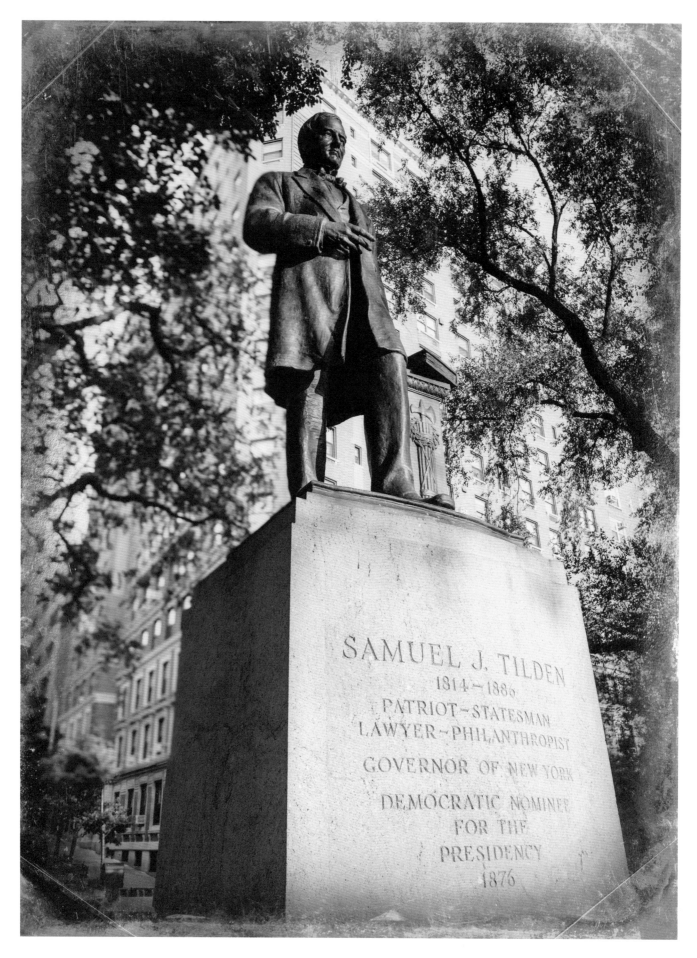

Samuel J. Tilden Monument, Riverside Park | New York, NY

SAMUEL TILDEN

Samuel Tilden was born in 1814 to a prosperous merchant descended from English settlers who arrived in America in the seventeenth century. Physically frail but intellectually precocious, he was introduced to politics by his father, a supporter of the Democratic Party. Despite being socially awkward, Tilden impressed others with his forceful intellect. His shrewd grasp of finance and investment led him to become wealthy while still young. Such was his investment acumen that he began to manage finances for others, including former president Martin Van Buren who was an early mentor.

Following in his father's footsteps, he was actively involved in Democratic Party politics. His introverted nature suited him for work as a party delegate and committee member rather than an office seeker. Tilden would have likely spent his whole life behind the scenes had he not been called upon to help protect the party's reputation from the avarice of William "Boss" Tweed.

Tweed controlled New York's Tammany Hall, one of the country's most powerful political machines. The political and economic elites of the state Democratic Party had largely tolerated Tammany's corruption as a means of controlling a sprawling city with a burgeoning working-class immigrant population. However, Tweed's unchecked greed was hard to ignore (he is estimated to have swindled as much as $45 million dollars). The financial mismanagement and corruption of New York City was likely to undermine the confidence of international investors, whose money was vital to sustaining the city and the state's success.

Party leaders finally realized that they needed to clean house. Tilden, as the state's Democratic Party chair, helped form the Committee of Seventy to advocate for more honest government. With characteristic forensic thoroughness, he analyzed bank accounts from Tweed's associates which helped establish proof of their guilt. For his efforts, he was awarded the Democratic Party nomination for New York State governor. After winning election, he continued his reform efforts by breaking up the "Canal Ring" which had been defrauding the state for maintenance and repairs on state canals.

Tilden's reputation for competence and honesty made him an ideal candidate for president in 1876 (much as a similar reputation would help another New York governor – Thomas Dewey – sixty years later). Overcoming his natural reserve, he

proved to be a capable campaigner. Tilden was the first Democratic candidate for president to win the popular vote in 24 years.

The Republican Party, however, was not ready to stomach a White House controlled by Democrats. Despite Tilden's victory, they challenged the election results. The shadow of a serious political conflict so soon after the Civil War threatened to destabilize the country.

There are few prizes that would be worth exchanging for the American presidency. However, the continued presence of federal troops in the South was a constant painful reminder that, over a decade after the end of the war, full civil government had still not been restored. The Democratic Party understood that, when troops left the South, the region (given its aversion to the Republicans) would become a reliable source of Democratic voters. The election stalemate ended with the Compromise of 1877, which guaranteed the removal of federal troops from the South in exchange for the Democrats agreeing to allow Republican Rutherford B. Hayes to assume the presidency.

Had Samuel Tilden been a more ambitious man – a firebrand like William Jennings Bryan or a fighter like Theodore Roosevelt – it is doubtful that such a compromise would have been possible. However, the Compromise of 1877 marked the true reunification of the country, allowing it to finally move past the trauma of the Civil War. Henceforth, American political energy could be directed into increasingly progressive directions, such as resolving class divisions in a world moving from an agrarian to an industrial model. Tilden's acquiescence to the Compromise of 1877 was arguably his greatest contribution to the country in a long lifetime of public service. He accepted the decision with impressive aplomb, saying "I can retire to private life with the consciousness that I shall receive from posterity the credit of having been elected to the highest position in the gift of the people, without any of the cares and responsibilities of the office."

Although he made an attempt to secure the Democratic nomination again in 1880, he was passed over in favor of Winfield Scott Hancock. A lifelong bachelor, he left behind a considerable fortune, a large portion of which went towards the creation of the New York Public Library – as great a monument as anyone might hope for.

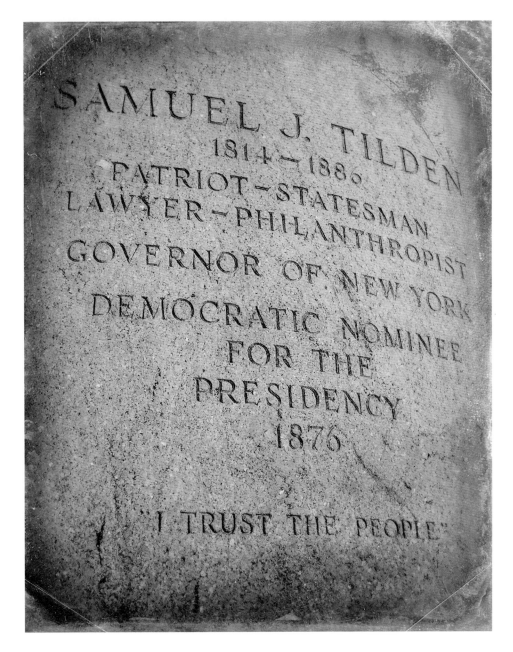

Detail of Samuel J. Tilden Monument

His formal public commemoration, a statue in New York's Riverside Park, avoids the excesses that plague many public monuments. It does not have him striking a neoclassical pose. Unprepossessing, it simply has him standing upright and stalwart as befits a man of the nineteenth century. At its base is a simple quote:

"I trust the people."

COPYRIGHT 1884, BY CURRIER & IVES. N.Y.

THE BIRD TO BET ON !

NEW YORK. PUBLISHED BY CURRIER & IVES, 115 NASSAU ST.

WINFIELD SCOTT HANCOCK

Born: 1824 Died: 1886

1880
DEMOCRAT

Defeated by:
JAMES A. GARFIELD

THE SUPERB

Among his many talents, Abraham Lincoln had a marked capacity for sizing up men. "When I go down in the morning to open my mail, I declare that I do it in fear and trembling lest I may hear that Hancock has been killed or wounded." Lincoln's high regard for Winfield Scott Hancock expressed sentiments shared by a multitude of Hancock's contemporaries.

What is striking is how many of his admirers came from the opposing side. After he successfully repulsed Pickett's Charge at the Battle of Gettysburg, the Confederates dubbed him "Thunderbolt of the Army of the Potomac." A lifelong Democrat, Hancock was remembered after his death by former Republican President Rutherford B. Hayes as being "through and through pure gold."

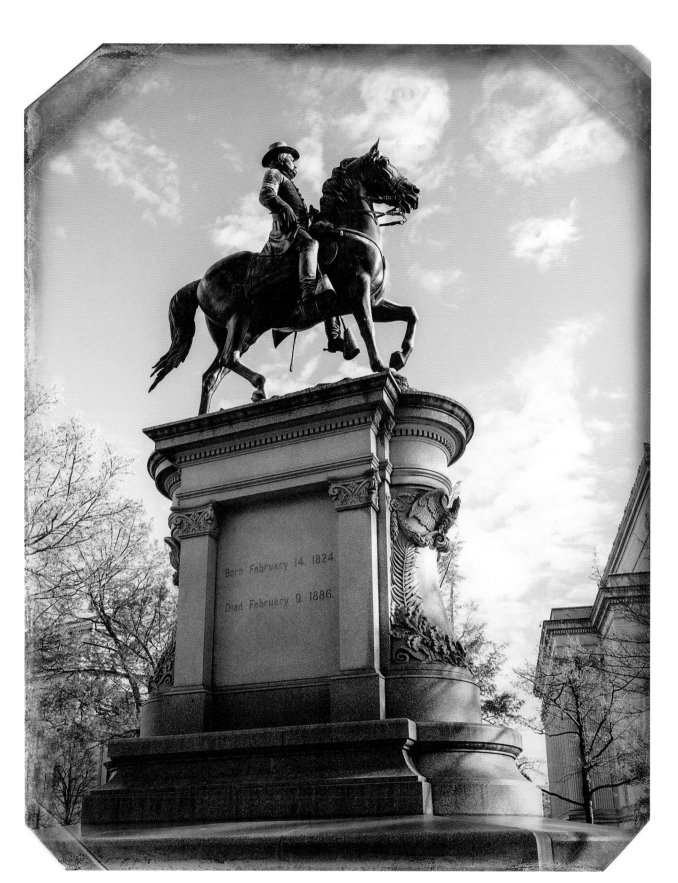

Born February 14, 1824.

Died February 9, 1886.

Pennsylvania Avenue & 7th Street | Washington, D.C.

WINFIELD SCOTT HANCOCK

W.S. Hancock was named after the great military figure of the age, Winfield Scott. (Scott was to the first generation of the young American republic the role model that George Washington had been for the revolutionary generation.) After a childhood in Pennsylvania, Hancock attended West Point. Like many young soldiers of the time, his first assignment was in Indian Territory. In 1847, he was transferred to duty in the Mexican-American War where he served under his namesake, General Scott. At the war's completion, he met and married Almira "Allie" Russell.

Prior to the Civil War, Hancock served in posts in Missouri, Minnesota, Florida, and California, which gave him an unusually broad perspective of the young, still-evolving nation. It also gave him opportunities to practice his gift for friendship with officers from other parts of the country. One of the most notable bonds he formed was with Lewis Armistead from Virginia, who would become a Confederate brigadier general. Both men were present at Gettysburg and both were wounded, with Armistead dying a few days after the battle. The story of their friendship would be one of the most poignant subplots of the 1993 film *Gettysburg*.

At the conclusion of the war, Hancock's status as a steady, capable commander led him to be assigned the grim task of supervising the execution of the conspirators of the Lincoln assassination plot, including Mary Surratt, the first woman to be formally executed by the federal government. He was then briefly stationed in the West, tasked with handling negotiations with Native American tribes, until President Johnson – critical of the way Republicans were handling Reconstruction – placed Hancock in charge of the Fifth Military District comprising Texas and Louisiana. When he arrived in New Orleans, he issued a general order which decreed that, so long as there was no public disorder, civilian administration should predominate with little interference from the military. In the written order, he expressed his fundamental political philosophy:

"The great principles of American liberty are still the lawful inheritance of this people, and ever should be. The right of trial by jury, the *habeas corpus*, the liberty of the press, the freedom of speech, the natural rights of persons and the rights of property must be preserved. Free institutions, while they are essential to the prosperity and happiness of the people, always furnish the strongest inducements to peace and order."

Hancock's position met with the approval of President Johnson and other conservative Democrats, but earned him little love among the Republicans still exerting the greatest political influence. When Ulysses Grant was elected president in 1868, Hancock was reassigned to a command in the West. During that time, he assisted the expedition to survey the region that would become Yellowstone National Park. In recognition of his support, the summit at the southernmost part of the Yellowstone area was named Mount Hancock.

Hancock's prestige as both a war hero and a just, fair-minded Reconstruction administrator made him a favorite in the Democratic party. When Samuel Tilden, the Democratic candidate in 1876, decided against running again in 1880, Hancock was chosen at the party convention on the second ballot. While Hancock did well in the South as expected, the Republicans undercut his support in the North by pointing out his opposition to a tariff that would favor industrial workers, an important voting bloc. In the end, the only Northern state Hancock carried in the election was New Jersey.

Unperturbed, Hancock attended the inauguration of his opponent James Garfield and resumed his military career, echoing the approach taken by his namesake decades earlier after Winfield Scott's own electoral defeat. Hancock's public appearances in his final years were few, such as the funeral of Ulysses S. Grant and a final visit to Gettysburg. He died in 1886 while still on active duty.

Hancock's equestrian statue on Pennsylvania Avenue in Washington, D.C., conveys a sense of heroic elevation. It was a good choice; few public figures so perfectly embodied the brave and thoughtful citizen as W.S. Hancock. After his passing, Francis Walker – noted economist and early president of MIT – expressed a sentiment likely shared by many of his contemporaries:

"Although I did not vote for General Hancock, I am strongly disposed to believe that one of the best things the nation has lost in recent years has been the example and the influence of that chivalric, stately, and splendid gentleman in the White House. Perhaps much which both parties now recognize as having been unfortunate and mischievous during the past thirteen years would have been avoided had General Hancock been elected."

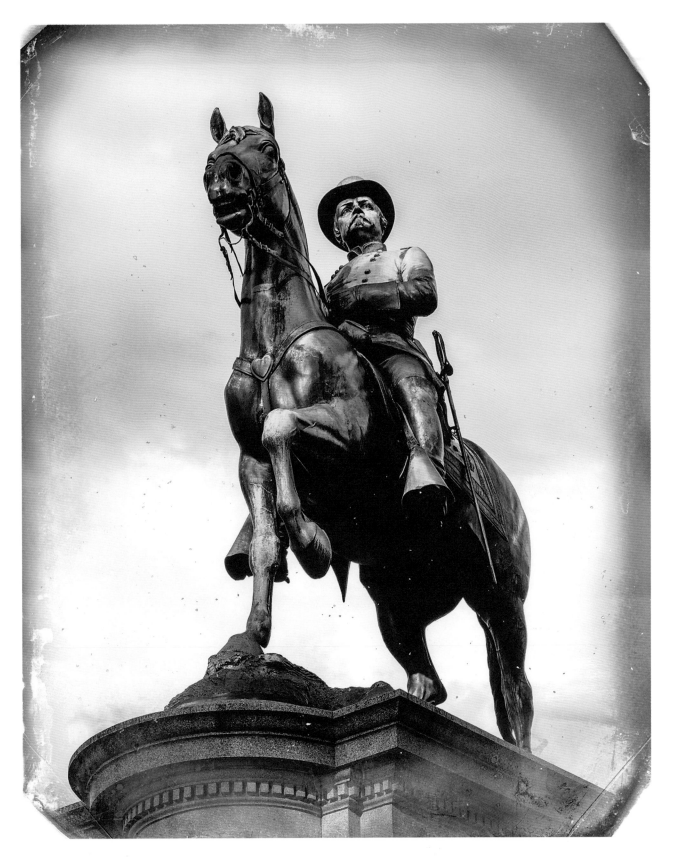

Detail of Winfield Scott Hancock Monument

FOR PRESIDENT
JAMES G. BLAINE,
OF MAINE.

FOR
VICE PRESIDENT
JOHN A. LOGAN
OF ILLINOIS.

JAMES G. BLAINE

Born: 1830 Died: 1893

1884
REPUBLICAN

Defeated by:
GROVER CLEVELAND

THE COMPANY MAN

Like old trunks in an attic, public buildings in America serve as repositories for things which have lost their practical utility but maintain sentimental value. In the archways of many of these buildings, the names of public servants are inscribed, politicians and civic leaders long forgotten by the communities they served.

The James G. Blaine School in Chicago is a perfect example. It is doubtful that students at the school have otherwise heard of Blaine. His invaluable efforts on behalf of civil service reform, for example, probably did not make it into their curriculum (a particular misfortune for Chicago).

Politicians laid low by their rivals and enemies are legion. James G. Blaine has the dubious distinction of having his presidential ambitions destroyed by a supporter.

In the 1884 presidential election, Blaine fought a close race against Democrat Grover Cleveland. Among the prizes sought were votes cast by large immigrant groups such as the urban Irish. Blaine's mother was Irish Catholic, so he could comfortably invoke kinship with these new voters. Moreover, he had long promoted an anti-British stance in American foreign policy.

What should have been a clear path to the White House after a long, albeit complicated, career in national politics was barred by the impetuosity of one Samuel D. Burchard. A Presbyterian minister and virulent anti-Catholic, Burchard supported the Republican Party in part because he saw the Democrats becoming enthralled to the immigrant groups from Europe. These new Americans, coming from largely Catholic countries such as Ireland, Italy, and Germany, were seen as a threat, barbarian hordes who would sap the Protestant vitality people like Burchard saw as essential to American life. "We are Republicans," intoned Burchard at a campaign rally, "and don't propose to leave our party and identify ourselves with the party whose antecedents have been rum, Romanism, and rebellion."

A canny Democratic operative attending the rally recorded the remark, which had either gone unnoticed by Republican campaigners or else dismissed as the typical overheated rhetoric of a campaign. The Democrats made certain the remark was printed in the newspapers, where it helped alienate Catholic swing voters who could have ensured Blaine's ascendancy.

The Civil War period abounded with epic leadership: Robert E. Lee and Stonewall Jackson on one side, Ulysses S. Grant and Abraham Lincoln on the other. The dynamo of war seemed to both produce and consume large amounts of America's leadership energies, leaving the following decades largely bereft of major national figures until the emergence of Theodore Roosevelt. The Gilded Age, which closed out the nineteenth century, was the Age of Managers.

If any American politician could serve as a representative of this group, it would be James G. Blaine. To look upon his photograph is to see a white-bearded, unsmiling man who could pass as a particularly gloomy storefront Santa. Shrewd, capable, organized, and articulate, he was the consummate "company man," a Republican Party true believer when machine politics filled the power gap left by the absence of strong, foresighted leaders.

JAMES G. BLAINE

Though not a visionary, he was a serious professional politician, capable of thinking about complex issues and crafting solutions in the interests of the country – and his party. He proposed greater trade with South America not only to increase America's commercial range, but to block increased European – specifically British – influence. It would also enhance the Republican Party's image as the "party of prosperity" by showing it as more sensitive to the interests of the business classes. More importantly, he was leader of the "Half-Breeds," a faction of the Republican Party that wanted to dismantle the spoils system of patronage and replace it with a permanent, professional civil service ("half-breed" because the resistance to patronage marked them as insufficiently loyal to their political party in the eyes of the "Stalwart" faction led by Roscoe Conkling, Blaine's bitter intraparty nemesis).

Despite his principled stand on civil service reform, Blaine – like many of his Gilded Age contemporaries – had a weakness for making shady deals. The publication of the infamous Mulligan correspondence (which appeared to implicate Blaine in an influence-for-money scheme) ended with the damning phrase, "Burn this letter." It was largely owing to the strength of his reputation that Blaine survived that crisis. However, the shadow of this scandal would return to plague him in the 1884 election. His supporters had hoped to bring down Grover Cleveland with the news that Cleveland had sired a child out of wedlock. The Democrats countered by reviving the memory of the Mulligan Letters, and Blaine's disavowal of any illegal deals, by shouting, "James G. Blaine, James G. Blaine, the continental liar from the state of Maine!"

Whether it was this or Reverend Burchard's prejudicial statements that cost Blaine the 1884 election, we will never know. Despite his many years in Congress (and two appointments as Secretary of State, under James Garfield and Benjamin Harrison), his name quickly fell into obscurity after his death in 1893.

If there is a Valhalla for those who aspire unsuccessfully to the presidency, then James G. Blaine should have a place of special honor at that table. He was the only man between 1860 and 1912 to receive the Republican nomination, yet fail to become president. His career illustrates the difference between prominence and greatness. Greatness emits a force which outlives the person it resided in. Prominence survives only as long as the man.

James G. Blaine Elementary School | Chicago, IL

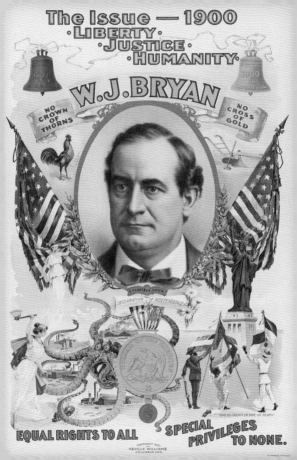

WILLIAM JENNINGS BRYAN

Born: 1860 Died: 1925

1896, 1900 & 1908
DEMOCRAT

Defeated by:
WILLIAM McKINLEY &
WILLIAM HOWARD TAFT

THE SAVIOR

Worse than being forgotten is to be misremembered.

In the 1950s, playwrights Jerome Lawrence and Robert Lee scored tremendous success on Broadway with their play *Inherit the Wind*, a fictionalized version of the 1925 Scopes Monkey Trial. The trial pitted two aging American titans, Clarence Darrow and William Jennings Bryan, against one another over the lawfulness of teaching evolution in American schools. Bryan, a devout Biblical traditionalist, took the position against evolution, while Darrow, the secular agnostic, defended it.

Inherit the Wind represents Bryan in the guise of Matthew Harrison Brady, a bombastic, self-important former presidential candidate whose glory has long since faded, a political has-been who sees the Monkey Trial's notoriety as a means of returning to the public eye so he can make yet another run at the presidency (Brady, like Bryan, has lost three presidential elections). The Brady character, although fundamentally good-natured, is deluded and pathetic. As the play makes painfully clear, he is yesterday's man, standing on the wrong side of history.

The play became a major Hollywood film, with Spencer Tracy as Henry Drummond, the Clarence Darrow character, and Fredric March as Brady/Bryan. *Inherit the Wind* has become a staple of American regional theater and been remade as a film for television several times. No enemy of Bryan in his lifetime could have wished for a better revenge upon him than the afterlife of his memory in American culture.

This is more our failing than Bryan's. To see Bryan as many of his contemporaries saw him, we would do well to gaze upon the statue of him that resides in his birthplace of Salem, Illinois, in what is called the Bryan Memorial Park triangle.

The statue originally resided in Washington, D.C., placed there in 1934 at the height of the Great Depression. Franklin Roosevelt gave the dedication, a politically astute gesture on Roosevelt's part, given Bryan's status as savior of the common people – a mantle Roosevelt needed to inherit to succeed as president during the worst economic crisis in the nation's history (and to prevent the drift of millions of heartland Americans into the arms of the hard left). Years later, long after the perils of the Great Depression receded, the statue was pulled down to make room for a new entrance to Theodore Roosevelt Bridge and left to gather dust in a vacant lot. The statue might still be in that ignominious place had not the citizens of Bryan's hometown decided that it was time for their native son to return. They arranged, at considerable expense and effort, to have the statue relocated to Salem, Illinois, in 1961.

In this monument, Bryan stands ramrod straight and tall, with a cape over his shoulders and his right arm over his head. He looks like a nineteenth-century superhero – which in a sense, he was.

That hero was known to millions as "The Great Commoner." In their minds, he

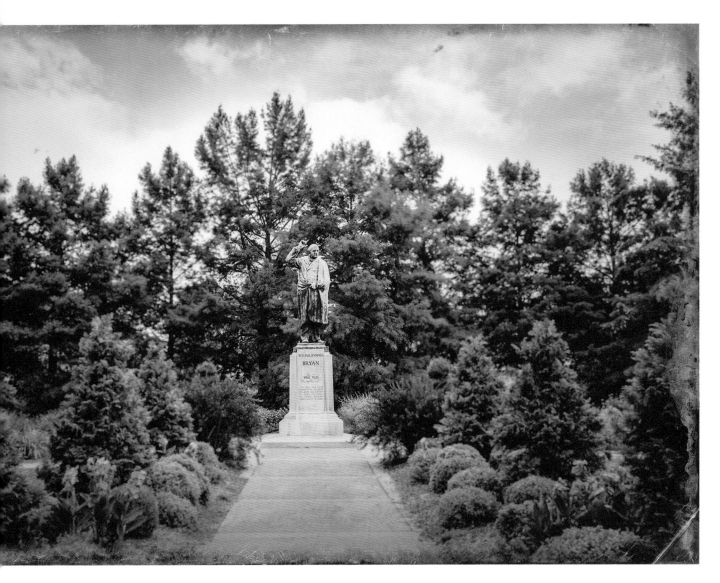

Bryan Memorial Park | Salem, IL

embodied the best qualities of an American man: plain-speaking, hard-working, family-cherishing, God-fearing. His superpower was a gift for oratory that set him apart even in an age rife with great stump speakers. He was a political savior to his followers, common men and women threatened by the rise of Industrial Age plutocrats and the shrinking power of traditional agrarian communities, displaced by big cities' concentration of wealth and power. His famous *Cross of Gold* speech at the 1896 Democratic convention thrilled listeners by reminding the world that civilization, for all its growing factory-based wealth, depended upon the simple farmer. "Burn down your cities and leave our farms," he intoned, "and your cities will spring up again as if by magic; but destroy our farms and the grass will grow in the streets of every city." This was quintessential Bryanism – apocalypticism wedded to class struggle. He linked Christianity's traditional regard for the poor and dispossessed with democracy's power to elevate and assist common people. He was the finest exemplar of a vanished breed: the evangelical leftist.

Though bright and energetic, Bryan was intellectually limited. He could expound eloquently on ideas that had come from other men, particularly Jefferson, but had no original insights. Worse, he had the failure of imagination common to the biblical literalist mindset. He saw political positions as moral imperatives: you were either on the side of the angels, or an instrument of the devil. Once he took a position, he rarely deviated from it. This resistance to change impressed his followers, who felt there were no leaders left who conveyed such firmness of purpose.

In a world that was undergoing rapid, unsettling change, Bryan was a fixed point.

This apparent strength would prove a fatal weakness to his legacy during the Scopes Trial. In the last month of his life, he would return to his long-abandoned roots as a lawyer and assist the prosecution in the case against John Thomas Scopes, a Tennessee teacher who had flouted state law by teaching evolution. Bryan was by no means anti-science, but he was troubled by scientific theories that challenged biblical descriptions of the world's origins. He was also concerned that Darwinism could be used to promote eugenics, a legitimate concern often overlooked by those who only perceived his stubborn resistance to modernity.

Bryan was on the wrong side of history at the Monkey Trial. However, no one should have their life's work dismissed simply for engaging in a public debate in their final

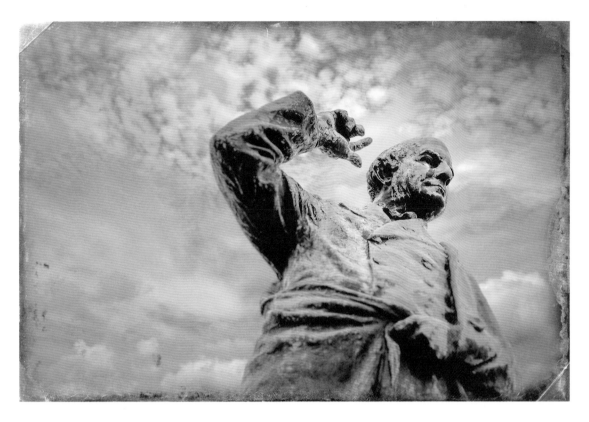

Detail of William Jennings Bryan statue

"You shall not press down upon the brow of labor this crown of thorns, you shall not crucify mankind upon a cross of gold."

days. In the years after the Civil War, America was a cauldron of ethnic strife and class struggle, inevitable growing pains that accompanied becoming the world's first continent-wide republic. Millions of people felt threatened and alienated, emotions that might have led to disaffection and revolutionary violence as in Europe. Through Bryan, these disenfranchised Americans felt they had a voice. As a presidential candidate, Bryan helped them channel their frustrations into a peaceful democratic outlet. He was the greatest tribune of ordinary, small-town America. And we are the better country for it.

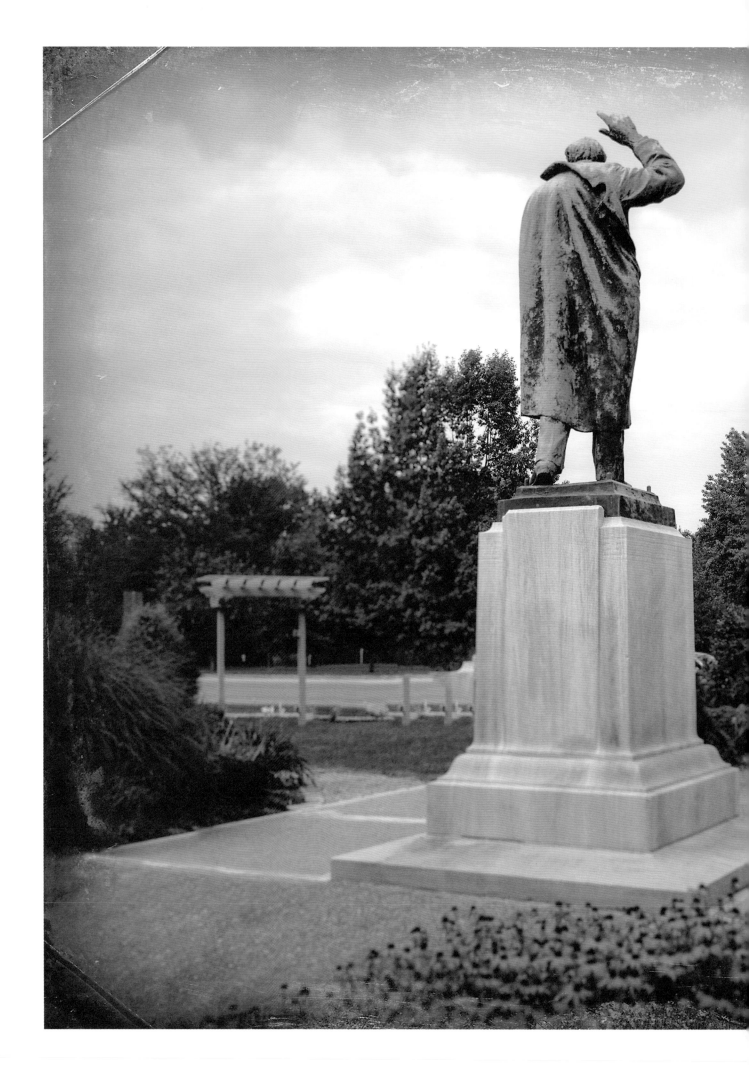

Back view, William Jennings Bryan statue

THE DEMOCRATIC PLATFORM OF 1904.

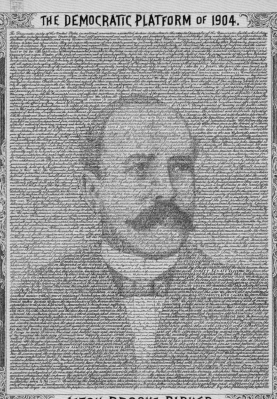

ALTON BROOKS PARKER.

ALTON B. PARKER

Born: 1852 Died: 1926

1904
DEMOCRAT

Defeated by:
THEODORE ROOSEVELT

THE REPLACEMENT

Theodore Roosevelt had a gift for making other men nervous. His barely contained energy, his boisterous way of speaking, his overwhelming physicality and brazen capacity for dominating people and events had an unsettling effect on the somnolent political establishment of the late nineteenth and early twentieth centuries, which for decades had contented itself with promoting quieter, more circumspect candidates – dependable fellows comfortable with subordinating themselves to the will of their party. Roosevelt's nomination as vice president on the 1900 Republican ticket had largely been a maneuver to neutralize what party boss Senator Mark Hanna of Ohio called "that damned cowboy" by consigning Roosevelt to a post which epitomized political limbo.

At the same time, Democratic Party leadership had to contend with its own maverick: the wily William Jennings Bryan, the prairie savior, whose oratorical appeal had revitalized a party which had lost much strength and national influence in the 1860s, when a good portion of its prominent leaders and voter base abandoned the Union to form the Confederacy.

Roosevelt and Bryan were perfect representatives of the Age of Industry – human dynamos capable of accomplishing remarkable things, but who could only be contained through strenuous effort and methodical management. At the turn of the twentieth century, the men leading the major political parties in the United States were not as advanced as their counterparts in the business and science communities at harnessing and controlling great forces of nature. In 1904, they attempted to resolve their dilemma by nominating someone who possessed all of the experience and sagacity needed in a good president, but with none of the charisma which could make him a force independent of an established political party. They chose Judge Alton Parker.

Parker, a native of New York State, had grown up in humble but respectable circumstances. He embarked on a career as a practicing lawyer active in Democratic Party politics. His ability and party affiliations enabled him to occupy a series of increasingly influential judicial posts, concluding with an appointment as Chief Judge of the New York Court of Appeals.

A presidential ascendancy by Parker could have helped both parties. If he were elected, he would displace Roosevelt, helping the Republican conservative establishment, and as a sitting Democratic president, weaken the influence of W.J. Bryan over the Democratic Party.

Parker's greatest asset was that he was disliked by no one. As a jurist, Parker was obliged to avoid publicly expressing opinions on divisive issues that might affect his ability to effectively adjudicate. This absence of partisanship allowed him to be acceptable as a candidate to both the conservative and radical elements of the Democratic Party. It also represented a genuine threat to Theodore Roosevelt, who understood that his forcefully held opinions and personality might be off-putting to part of the electorate.

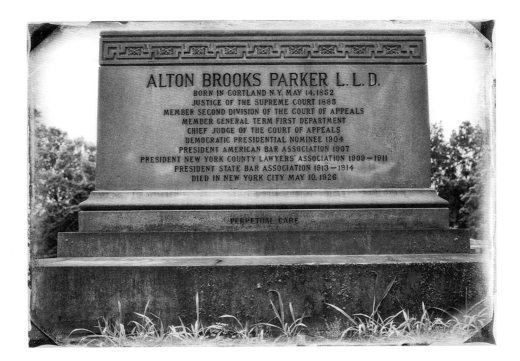

Parker family gravesite, Wiltwyck Cemetery | Kingston, NY

As Roosevelt put it, "the neutral-tinted individual is very apt to win against the man of pronounced views and active life."

The problems for Parker lay chiefly in two areas. One, he was challenging an incumbent, Roosevelt having risen to the presidency after the death of William McKinley.. Two, there was little substantive difference between him and Roosevelt on major issues. Both men were products of the Eastern establishment and shared a fundamentally similar worldview and set of values. The election of 1904 was really a choice between personalities, not positions.

In the end, Roosevelt had little to worry about. America was ready for a big man in the White House and handed Roosevelt a decisive victory in both the popular and electoral votes. In addition, the death of Mark Hanna in 1904 deprived his Republican critics of their leading challenger to Roosevelt's party dominance. Alton Parker, having done his duty for the Democrats, returned to the quiet but civically engaged life he had known before the election. Although he would continue to be active until his death in 1926, Parker left no residual awareness in the public mind. He belongs to that coterie of candidates who were distinguished but not distinctive.

MARY LOUISE PARKER
NÉE SCHOONMAKER
DIED APRIL 2, 1917
SHE FILLED WITH FIDELITY AND GRACE EVERY
PLACE IN LIFE TO WHICH GOD CALLED HER

JOHN M. PARKER
SON OF ALTON BROOKS AND MARY LOUISE PARKER
DIED MAY 7, 1883
AGED 7 YEARS

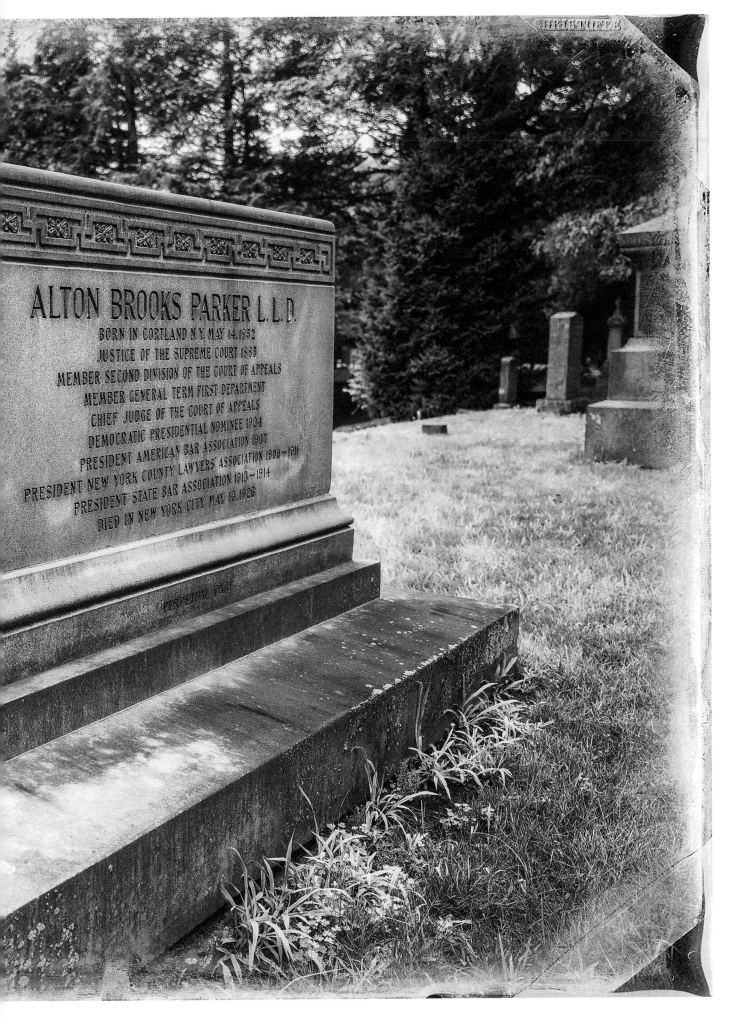

ALTON BROOKS PARKER L.L.D.
BORN IN CORTLAND N.Y. MAY 14, 1852
JUSTICE OF THE SUPREME COURT 1885
MEMBER SECOND DIVISION OF THE COURT OF APPEALS
MEMBER GENERAL TERM FIRST DEPARTMENT
CHIEF JUDGE OF THE COURT OF APPEALS
DEMOCRATIC PRESIDENTIAL NOMINEE 1904
PRESIDENT AMERICAN BAR ASSOCIATION 1907
PRESIDENT NEW YORK COUNTY LAWYERS' ASSOCIATION 1909 – 1911
PRESIDENT STATE BAR ASSOCIATION 1913 – 1914
DIED IN NEW YORK CITY MAY 10, 1926

PERPETUAL CARE

Parker family gravesite, Wiltwyck Cemetery

CHARLES EVANS HUGHES

Born: 1862 Died: 1948

1916
REPUBLICAN

Defeated by:
WOODROW WILSON

THE PUBLIC SERVANT

It was the hope of the nation's founders that the country would always be led by sober-minded men of exceptional ability and staunch character, men with values informed by the Protestant ethos which the original settlers had brought to America, men free to pursue the public interest without regard to political faction or private interests.

Charles Evans Hughes was everything they could have dreamed of.

Born in Glen Falls, New York, Hughes's father was a Welsh-born minister and his mother the sister of a state senator. Like other also-rans, he demonstrated exceptional intellectual skills early in life, matriculating at age 14 to what would one day become Colgate University. Later, he transferred to Brown University, graduating third in his class, then attended Columbia University School of Law, where he graduated with high honors. He joined the law firm of Chamberlain, Carter & Hornblower; when he became a partner in the firm, the name was changed to Carter, Hughes & Cravath. Hughes served for a time as a professor at Cornell Law School and at New York Law School, where one of his fellow professors, Woodrow Wilson, would be his eventual rival for the presidency.

Like other members of the presidential candidate fraternity, Hughes gained prominence helping to investigate a violation of the public trust. He was recruited to the Stevens Gas Commission looking into monopolistic practices in the utilities industry. Hughes, stiff and formal, initially made a negative impression on the newsman covering the story, who portrayed him as an "iceman." However, he quickly demonstrated an extraordinary forensic ability as he moved through the records of the utility companies – contracts, letters, cleared checks – to discover evidence of rate manipulation and bribery, evidence he displayed in court and explained in precise, clear detail so the public could understand. One awed journalist said:

"What we had been seeing is not a machine, not an iceman, but a master craftsman, an artist, an architect of law and order and justice."

Hughes's success with the Stevens Commission made him a natural candidate for public office. At the encouragement of Theodore Roosevelt and others, he ran for governor of New York in 1906 against publisher William Randolph Hearst. Hughes's victory was made all the more significant by the fact that he was the only Republican to win statewide office. In 1908 he declined an offer from William H. Taft to serve as vice president in order to continue as governor of New York.

Honorary room within the New York City Bar Association | New York, NY

Taft found the perfect role for Hughes once he left the governor's office in 1910: as an associate justice on the Supreme Court. (Ironically, this was a role Taft himself had always coveted – more so than the presidency, which Taft had to be persuaded to pursue.) In many respects, being a Supreme Court justice was the job for which Hughes was intellectually and temperamentally best suited. He would have likely stayed at the Court if the call to draft him in 1916 to run against Woodrow Wilson had not been so strong.

In 1912, the Republicans had lost the presidential election because of a war between progressive Republicans, who wanted Theodore Roosevelt to serve again, and the conservative Republicans represented by Taft, Roosevelt's hand-picked successor from whom he had become estranged. When Taft was renominated, the progressives bolted and formed their own "Bull Moose" party which siphoned away key votes, ensuring Wilson's victory.

In 1916, Republicans needed a figure who could reunite the party. Hughes was seen as one of the Republican Party's most respected members, a universally esteemed figure who could bring together the warring factions and attract votes. As a party stalwart, Hughes allowed himself to be drafted and resigned from the Court.

The election of 1916 was a contest between two men so similar in background and temperament that they could have been mistaken for twins. Both were sober-minded intellectuals who had held professorships and served successfully as governors of neighboring states. Both had a reputation as brilliant but aloof. This, of course, did not help Hughes's position. In order to defeat an incumbent president, the opposing candidate must offer some substantial alternative to the status quo. Hughes could thoughtfully articulate the shortcomings and mistakes of the Wilson administration, but could not paint a compelling vision of what a Hughes presidency would do differently.

This was where the temperaments of Wilson and Hughes diverged. Wilson possessed a creative political imagination that found its best expression in foreign policy, where he foresaw an expanded role for the United States to, as he would eventually say, "make the world safe for democracy." Wilson's distinctive philosophy, stated in his famous "Fourteen Points" at the close of World War I, articulated a vision for the United States' role in global affairs as the defender of democracy – a school of thought that today bears his name as "Wilsonianism." Hughes, by contrast, lacked a capacity for grand ideas. He attracted admirers, but not followers.

Still, he came close to defeating Wilson. His great miscalculation was his failure to cultivate Hiram Johnson, the influential Republican progressive governor from California. When Hughes and Johnson stayed at the same hotel in Southern California, Hughes failed to seek out Johnson during the stay, which Johnson took as a personal slight. It helped evaporate support for Hughes in the state. Hughes later claimed

that he was unaware of Johnson's presence and stated, "If I had known that Johnson was in the hotel, I would have seen him if I had been obliged to kick the door down."

Hughes lost California and its crucial Electoral College votes in the general election. This misfortune, along with the momentum Wilson gained with his pithy campaign slogan ("He kept us out of war"), swung the election to Wilson.

Despite his loss, Hughes's chances at success were sufficiently strong for Wilson to prepare an unusual contingency plan. Realizing that war with Germany was unavoidable, Wilson considered appointing Hughes as Secretary of State during what would have been the last few months of Wilson's administration. Wilson and his vice president would then resign, allowing Hughes to become president immediately and avoiding a lame-duck period with a disempowered president.

Ironically, Hughes's loss in the presidential election laid the foundation for his most fertile period of public service. Appointed Secretary of State in 1920, Hughes gave the country some sense of stability during the erratic and inept administration of Warren G. Harding. Once his term in office was completed, he returned to private practice for a few years before being reappointed by President Hoover to the Supreme Court, where he succeeded Taft as chief justice. (Hoover also appointed Hughes's son, Charles Evans Hughes, Jr., as the solicitor general.)

As chief justice, Hughes skillfully navigated the Supreme Court through the tumult of the Great Depression, when there was considerable friction between President Franklin Roosevelt and the more conservative members of the court. Hughes helped shield much New Deal legislation from attacks by conservative justices, while successfully resisting Roosevelt's attempt to stack the court with an increased number of justices favorable to his policies. Hughes retired from the court in 1945 and died in Massachusetts in 1948 at the age of 86.

He was a gifted, congenial, and incorruptible man, an embodiment of that American archetype that began with John Adams: the exceptional man who finds meaning in serving the common man, a democratic elitist. Like Adams, Hughes believed deeply in a code of personal honor and a life spent in public service. As Hughes himself put it, "A man has to live with himself, and he should see to it that he always has good company."

JAMES M. COX

Born: 1870 Died: 1957

1920
DEMOCRAT

Defeated by:
WARREN G. HARDING

THE BETTER MAN

It is a widely accepted truism that the age of television undermined the ability of the American electorate to select the best candidate for president. Bombarding voters with carefully managed images has caused the average person to favor appearance and style over substance, leading to the triumph of the telegenic candidate over the thoughtful one. The outcome of the election of 1920 suggests that was a problem long before the age of mass media. Warren G. Harding, perceived as handsome but superficial, won a landslide victory over James M. Cox, seen by many Americans as a man of greater substance and gravitas than Harding.

Cox was born and raised in Ohio. A self-made man, he succeeded first as a working journalist, then as the owner of a series of newspapers before entering politics. Cox served first in the House of Representatives, then several terms as governor of Ohio. Despite his achievements, he was not a first-ballot selection in 1920. It was only after a deadlock among the leading contenders that he was chosen. Stolid and dependable, he lacked the charisma necessary to woo voters ready for a change after eight years of Democratic governance under Woodrow Wilson.

Warren Harding, Cox's rival, was also an Ohio newspaperman who had turned to politics, serving first as a state senator before entering the US Senate. Harding has often been portrayed as a handsome dunce whose presidency was ruined by his inability to select honest men for his cabinet. This is a distorted picture. Harding was an intelligent man, well-liked and popular throughout most of his career, including his presidency. He was shrewd enough to seize upon a potent campaign message in 1920, advocating a "return to normalcy." He expanded on this theme:

"America's present need is not heroics, but healing; not nostrums, but normalcy; not revolution, but restoration; not agitation, but adjustment; not surgery, but serenity."

After the turmoil of the First World War and the enormous upheaval it brought, Harding's conservative message hearkening back to a simpler prewar world had a powerful appeal.

In the end, Harding's ticket (which included Massachusetts governor Calvin Coolidge) won sixty percent of the popular vote, trouncing Cox and his running mate, up-and-coming young Democratic leader Franklin Roosevelt. Cox retired from politics and devoted his remaining decades (he died in 1957) to his expanding media empire, Cox Enterprises.

Dayton International Airport | Dayton, OH

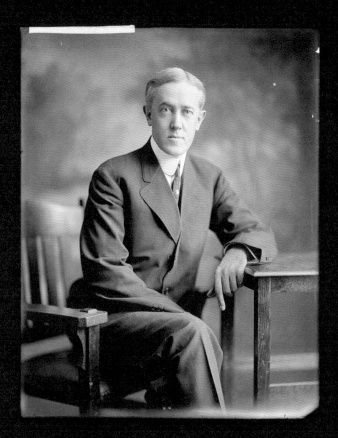

JOHN W. DAVIS

Born: 1873 Died: 1955

1924
DEMOCRAT

Defeated by:
CALVIN COOLIDGE

THE JEFFERSONIAN

Like so many candidates for the presidency, John W. Davis came from a distinguished line of accomplished individuals. His father was a prominent attorney in Virginia, a Southerner who stayed loyal to the Union during the Civil War. The elder Davis helped sever the upper regions of that state from the rebellion to create the separate state of West Virginia (which, as writer Christopher Hitchens once observed, was the only truly successful act of secession to survive the war). Yet, this act of loyalty to the United States was not a reflection of any attachment to the worldview of Abraham Lincoln. The Davis family embodied Southern Democratic conservatism. While in his prime, John W. Davis lent his ability to the progressive initiatives of the Democratic Party, he would remain conservative in other respects. (In the last years of his life, he provided legal support to defend school segregation during the *Brown v. Board of Education* case before the Supreme Court.)

The Davis family staunchly believed in the limited-government view advanced by Thomas Jefferson. Davis himself was born on the same date as Jefferson – a feat some saw as a peculiarly personal expression of the family's attachment to Jefferson. Davis was homeschooled until the age of ten, then attended a college prep school to prepare for entrance to Washington and Lee University. He studied the law as a clerk in his father's office.

He worked his way up the professional chain via the reliable formula of hard work, exceptional legal ability, and consistent service to his political party. He had time for little else; his first wife died a year into their marriage, leaving him with a young daughter. It would be over a decade before he remarried.

Davis resembled his contemporary and fellow presidential aspirant Charles Evans Hughes in that his intellect and character made him acceptable to both the establishment and the masses. He served the Democratic Party faithfully for several years from behind the scenes as a local party chairman in West Virginia, but like Hughes, Davis was ambivalent about seeking elected office: "John W. Davis has been kicked into every office he ever held," a saying went.

Davis was finally cajoled into his first political office as a congressman in 1911. His ability and efforts for the party brought him to the attention of Woodrow Wilson, who named him solicitor general, a role in which he appeared often before the Supreme Court. He became friends with Wilson and would serve as one of the president's advisors at the Paris Peace Conference following the close of World War I. His political experience was further broadened when he was appointed ambassador to Great Britain from 1919 to 1921.

After serving in Wilson's administration, Davis became a prominent Wall Street attorney. He might have stayed in this role had he not been propelled into the 1924 Democratic nomination. Davis was drafted as a compromise candidate to resolve deadlock between party delegates who favored Al Smith of New York and supporters of William G. McAdoo, Woodrow Wilson's son-in-law. Had he faced Warren Harding in the election, Davis might have won, given how disastrous and scandal-plagued Harding's administration had become. However, Harding's death from an apparent heart attack had led to the ascendancy of Calvin Coolidge. "Silent Cal" possessed a chilly, charm-free personality,

JOHN W. DAVIS

Washington and Lee University dormitory | Lexington, VA

but he projected an essential honesty and administrative competence. Davis, for all his positive traits, lacked the charisma necessary to unseat a sitting president in prosperous times. Moreover, Davis had to contend with the disruption created by the independent candidacy of Governor Robert LaFollette of Wisconsin, which doubtlessly drained votes that might have gone to the Democrats.

After his defeat in the 1924 election, Davis returned to his Wall Street practice. He remained one of the leading lawyers in America, serving briefly as president of the American Bar Association. He presented 140 cases before the Supreme Court and continued on for decades as a quiet, behind-the-scenes member of the establishment. However, his fierce Jeffersonian impulses spurred him to challenge the overreach of a fellow Democrat in 1952, when he argued against President Truman's seizure of the steel mills and won his case before the Supreme Court. This victory should have been the capstone of his career. Instead, it was overshadowed by his defense of South Carolina's segregationist policies in *Brown v. Board of Education*.

In both cases, Davis stayed true to his interpretation of Jefferson's America, where the government, though centralized, had clear limits on its power to interfere in the lives of its citizens. In his actions, John W. Davis illustrated both the strengths and weaknesses of the Jeffersonian vision.

AL SMITH

Born: 1873 Died: 1944

1928
DEMOCRAT

Defeated by:
HERBERT HOOVER

CITY BOY

American exceptionalism can be summed up in four words – *poor boy makes good.*

For the first hundred years after the founding of the country, this usually meant young men from farms and rural communities. As the *New York Times* would note in its obituary of Al Smith: "There have been country boys in plenty, such as Lincoln and Garfield, who rose to the heights, but no other city urchin . . . ever rose so superior to his lack of youthful advantages and had so distinguished a public career."

Smith was a perfect representative of post-Civil War America, in which the major sources of political energy moved from the countryside to big cities like Chicago and New York and mill towns like Lowell, Massachusetts, and Pawtucket, Rhode Island, fueled by the rise of factories and waves of immigrants from Europe. Smith's successes owed much to these new Americans. His one great political failure owed everything to the prejudices of the older ones.

Born on South Street in Manhattan, he was raised in a Lower East Side tenement within sight of the Brooklyn Bridge; "The Brooklyn Bridge and I grew up together," he once quipped. His mother Catherine was Irish Catholic, the daughter of immigrants from County Westmeath, Ireland; his father Emmanuel the son of Italian and German immigrants. A Civil War veteran, Smith's father followed the not-uncommon practice of anglicizing his family name. Despite his mixed heritage, Al Smith would identify most strongly with the Irish, his mother's people.

When Smith was thirteen, his father died. As the son of a poor widow, Smith's formative years would mirror those of countless other working-class city dwellers. Forced to leave school to find employment, he worked first in the family store, then as an errand boy, a clerk, and finally as a fishmonger in the Bronx. Working seven days a week from five a.m. to six thirty p.m., Smith did everything from unpacking fish to slicing and selling them. Years later, reflecting on his informal education, he would say, "I have only one degree – FFM – Fulton Fish Market."

Always sociable, he engaged in amateur theatrics with his friends, putting on plays and developing the public speaking skills that would benefit him in his later career. At 22, his hard work, intelligence, and geniality were rewarded with his first political job, as a process server for the Commissioner of Jurors. A position as a district leader followed, and at the age of 30, he was elected to the New York State legislature as an assemblyman.

His first term as assemblyman was challenging, as he lacked the benefits of formal education that many of his colleagues in Albany possessed. However, showing the same Olympian work ethic he had demonstrated at the fish market, Smith stayed up nights reading carefully over every bill, wrestling with the arcane language in which they were composed; years later, he would make a point of having state legislation written in simpler language so that common people could better

understand what was being proposed. His efforts, combined with a remarkable memory for detail, gave him an understanding of legislation and legislative process unmatched in his day.

This, along with his gift for oration and personal conviviality, made him a rising star who caught the attention of Tammany boss "Silent" Charlie Murphy. Murphy, a shrewd appraiser of political talent, understood the value of a brilliant, honest young politician of hardscrabble origins with whom millions of working-class voters could identify. After a personal interview, one of Murphy's advisors pointed out that Smith had never attended college. Murphy responded, "If he had gone to college, he wouldn't be Al Smith."

The transformative event of Smith's early career was the 1911 Triangle Shirtwaist Factory fire, a notorious example of sweatshop labor abuse. The factory was located on the upper floors of a building in Greenwich Village. When fire broke out, the largely immigrant workers were unable to escape because the owners had locked the doors to prevent theft of merchandise. One hundred and forty-six people lost their lives.

Public outrage fueled a call for legislation to protect the lives and rights of ordinary workers. Charlie Murphy arranged for Smith, by then head of the state assembly, to head the investigation along with Robert Wagner. Smith zealously interviewed eyewitnesses and visited dozens of factory sweatshops. He would become a tireless fighter for progressive policies, passing legislation to address child labor, disability support, and women's rights in the workplace. Smith enabled laws that the reform movement had struggled for decades to pass. In doing so, he created an effective model that would be followed by other progressive politicians, most notably fellow New York Democrat Franklin Roosevelt. Years later Frances Perkins, an ally of Smith's who served as Secretary of Labor under Roosevelt, would say, "the New Deal began on March 25, 1911, the day of the Triangle Shirtwaist Fire."

In 1919, Smith was elected governor of New York. His election to the highest office in the state, traditionally reserved for the Protestant elite, was a milestone for working-class immigrants and their children. Over three nonconsecutive terms he served close to eight years as governor.

His success as a campaigner – winning twenty out of twenty-one campaigns – and his sterling record as a forward-thinking, dynamic public servant made Smith and others begin to envision a run for the White House. He made his first attempt to gain the Democratic nomination in 1924, with Franklin Roosevelt dubbing him "the happy warrior" in a convention speech. He did not succeed that year, but in 1928 received his party's nomination at the convention in Houston, Texas.

The nomination was the crowning achievement of Smith's political career. Never before had a Catholic received the nomination from a major political party. In some ways, it was as much a shattering of a glass ceiling in American politics as Barack Obama's nomination eighty years later.

Nevertheless, the probability of Smith's success was never great. The country was experiencing a period of prosperity, which benefited the incumbent Republicans. In addition, Smith was a known opponent and critic of Prohibition. As Daniel Patrick Moynihan observed, "Prohibition was the final effort of fundamentalist Protestantism to impose an ethic on post-Protestant America." In other words, it was an unsubtle strike by nativist Americans against the new – largely Catholic – immigrant communities.

For decades, rural-based Protestant Americans nursed resentment against the growing power of the urban masses. These were the people who William Jennings Bryan and the Democratic Party had represented in the past. By 1928, the banner of the American working man had shifted to the city dweller, someone whose parents or grandparents had probably been born outside the United States.

What better way for small-town America to express its distaste and hostility for city folk, than to reject the man who was the tribune of the New Americans? Smith's failed candidacy has long been presented as a consequence of anti-Catholicism, which to a significant degree it was. However, it was also a victim of tribal animosity, of Old America against New America.

Smith's lack of experience with (and understanding of) people outside of New York was another considerable handicap. His distinctive "New Yawk" accent, played on the radio, sounded to many Americans in the South and Midwest as though they were being addressed by someone from another country.

All these factors combined to propel Herbert Hoover to one of the biggest landslide victories in American history; he even took New York State. For Smith, who had enjoyed immense popularity and support throughout his career, it was a crushing blow.

As he had vacated the governor's chair to make way for his colleague Franklin Roosevelt (whom he regarded as an ingratiating dilettante), Smith was left without a clear role for the first time in decades. His campaign manager, John J. Raskob, was a financier who aspired to create the largest building in the world – the Empire State Building. He made Smith president of the company in charge of the project.

Smith would remain in business during the final sixteen years of his life. His version of progressivism was to use government to curb abuses by business and use public resources to improve the general living conditions of the public. Unlike other progressives, he was never antagonistic to big business in general. Instead, Smith's philosophy emphasized the importance of all parties coming together to forge mutually productive agreements.

As such, he became extremely critical of Franklin Roosevelt as president, believing that Roosevelt – although he was building on approaches to government pioneered by Smith – was too critical of the business community. He was also fueled by a resentment of Roosevelt, who copied many of his best ideas. Smith, however, remained good friends with Eleanor Roosevelt; so much so that she invited Smith to stay at the White House even when Smith was publicly attacking her husband.

Smith died in 1944, only a few months after his wife. Like other politicians of his era, his story would be overshadowed by that of Franklin Roosevelt, remembered as the political giant of the age. Yet without Smith's ideas and influence, it is unlikely that Roosevelt could have been as great a success as he became. Smith's career in New York was a testing ground for ideas and practices which would become fundamental to the progressive agenda in American politics.

In his 1928 presidential campaign, Smith won the vote in the twelve biggest cities, creating the urban voting coalition upon which the Democratic Party would depend for decades to come. Thirty-two years after Smith, another Democratic candidate would combine Smith's Irish-Catholic roots with Roosevelt's patrician charm and

Empire State Building | New York, NY

win the presidency, thus completing the quest that Smith had begun to widen the field for American presidential candidates of different faiths.

While there are a number of public buildings named in honor of Smith, he has two truly lasting monuments. One is the Alfred E. Smith Dinner, held every four years in the Diocese of New York, which brings together the two presidential nominees for an evening of fellowship in which the candidates get to poke fun at themselves (and each other) in a spirit of friendly competition. The dinner is an increasingly needed reminder of what Smith knew so well: that democracies need a neutral place where political antagonists can briefly forget their differences and come together in a shared celebration of their love of country and their common humanity.

The other is the Empire State Building, for decades the largest building in the world and a perfect symbol of the bold, reach-for-the-skies mentality that Americans in general – and New Yorkers in particular – possess. Smith understood that business leaders and working men and women could come together to create something magnificent, of which they could be mutually proud. He was always an optimist and he believed the people he represented, no matter how difficult their lives, were fundamentally optimists as well:

"The American people never carry an umbrella. They prepare to walk in eternal sunshine."

ALF LANDON

Born: 1887 Died: 1987

1936
REPUBLICAN

Defeated by:
FRANKLIN D. ROOSEVELT

THE GENTLEMAN FROM KANSAS

In his 1969 novel *Mr. Bridge*, Evan S. Connell created an indelible portrait of a certain type of American man living in the Midwest during the years between the two world wars. Walter Bridge is a sober, hardworking husband and father who practices law, invests prudently in low-risk investments such as public utilities, attends church and belongs to the local country club. Walter is a decent, if emotionally repressed, pillar of his community. It can be safely assumed that, in the 1936 presidential election, Walter Bridge would have voted for Alf Landon.

Landon personifies a distinctly American figure: the taciturn Midwesterner, an antithesis to the more voluble figures found in Texas and the Southwest. If the prototypical Texan is larger than life (think Lyndon Johnson), the Midwesterner is his introverted opposite. The flat, undramatic geography of the Midwest – and the concentrated effort needed to make its soil productive – has shaped generations of its inhabitants, breeding a cautious, careful people who avoid unnecessary risk and who place their faith in patient, steady work, the original quiet Americans.

Alf Landon was born in Pennsylvania and grew up in Ohio, moving to Kansas to attend university and staying there the rest of his very long life. He was an oilman who built on his father's work and became a millionaire before following his ambition to make a run at politics. He was a member of that fondly recalled, now-extinct breed known as liberal Republicans, men and women who adhered to what Landon once called "practical progressivism," a creed which did not pursue change for change's sake. Liberal Republicans understood that as the nation evolved and grew more complicated, new solutions would need to be adopted, although implemented in a slow, steady manner without threatening the bedrock principles on which the country had been built.

By the conclusion of Franklin Roosevelt's first term in office, it was clear that Roosevelt favored bold, often radical solutions to the problems posed by the Great Depression. Roosevelt possessed the carefree recklessness of the aristocrat. Along with his penchant for political experimentalism, it was this quality that antagonized the conservative elements of the country. Landon had been elected governor of Kansas in 1928 and returned to office in 1934, and was one of the few Republicans of any stature who could conceivably challenge Roosevelt.

Landon had two great disadvantages. First, he lacked the genius for campaigning, the dramatic flair that made Franklin Roosevelt such a compelling figure. Roosevelt had already begun to use the radio as a means of connecting with voters around the country. Landon had little charm to offer, on the stump or in front of a microphone. His second disadvantage was the mood of the country. In a more prosperous period, Landon's "play it safe" approach would have been reassuring. In 1936, it reminded people too much of the passivity that had caused them to turn Herbert Hoover out of office. Landon's defeat in the 1936

Kansas State University Landon Lecture Series | Manhattan, KS

presidential election was colossal – he won only 8 electoral votes to Roosevelt's 523. If anything, it helped cement Roosevelt's aura as a political giant, an Olympian figure nearly impossible to dethrone.

It also marked the end of Landon's political career. He returned to business and the life of a highly respected private citizen. In the decades ahead, he would maintain his allegiance to the level-headed pragmatism that informed the liberal Republican outlook. His most lasting contribution to politics was his daughter Nancy, a child of his second marriage, who would represent Kansas in the Senate for twenty years.

Landon had the distinction of outliving the man who defeated him by a great many years. While Roosevelt died in 1944, Landon lived until 1987, dying a month after reaching his 100th birthday. His name lives on in a speaker series at Kansas State University in which a number of distinguished Americans, including former presidents like Richard Nixon, have participated.

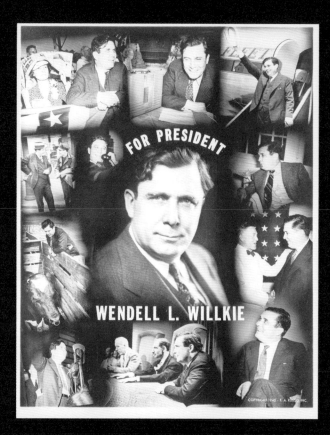

FOR PRESIDENT

WENDELL L. WILLKIE

COPYRIGHT 1940 · F. A. BUSCO, INC.

WENDELL WILLKIE

Born: 1892 Died: 1944

1940
REPUBLICAN

Defeated by:
FRANKLIN D. ROOSEVELT

DARK HORSE

There is something woefully inadequate about commemorating a life with a flat, colorless, one-dimensional plate pressed against a concrete wall.

This poor judgment is particularly egregious when one considers the life of Wendell Willkie. A feisty, big-hearted bantam rooster of a man, Willkie came as close as any presidential candidate to stealing the hearts of American voters away from Franklin Roosevelt.

An Indiana native, Willkie began his career as a corporate lawyer in Ohio, eventually becoming president of Commonwealth & Southern, a private utilities company that supplied energy to eleven states. Socially liberal, he was a Democrat when Franklin Roosevelt became president, even donating $100 to Roosevelt's campaign (later, after becoming disillusioned with Roosevelt's domestic policies, Willkie expressed a wish that he had gotten his money back).

Roosevelt's creation of the Tennessee Valley Authority to create cheap electricity was seen by Willkie as an encroachment by big government into a sphere best served by competing private enterprise. This aspect of Roosevelt's New Deal program was troubling to many Americans, not just those who ran big businesses. Taken too far, it could erode the entrepreneurial spirit and self-reliance that was the traditional engine of American society. This, combined with Roosevelt's drive for increased government regulation of business, drove Willkie into the Republican Party.

Willkie's threat to Roosevelt, paradoxically, was not because he was so different from Roosevelt in outlook, but because he was so similar. Like Roosevelt, he was socially liberal and believed that America had an important role to play in international affairs. He differed from Roosevelt only in his attitude towards business. As Willkie told a crowd during the campaign:

"I'm in business and proud of it. Nobody can make me soft-pedal any fact in my business career. After all, business is our way of life, our achievement, our glory."

Roosevelt, an aristocrat whose inherited wealth ensured his lifelong financial independence, never acquired an appreciation for the toil it takes to create wealth.

By running for re-election again in 1940, Roosevelt broke the tradition of presidents limiting themselves to two, four-year terms, a practice begun with George Washington. This fueled arguments that Roosevelt was setting himself up as a virtual dictator, but no one in the Republican establishment could match

WENDELL WILLKIE

Roosevelt's charisma and public support. Willkie, however, appealed to people who favored Roosevelt's social policies but found him too anti-business, and who regarded the idea of a three-term president as un-American.

As welcome as Willkie was into the Republican ranks, the fact that he was a former Democrat made some skeptical about his suitability as a presidential candidate. The Republican senator from Indiana told Willkie flatly, "It's all right if the town whore joins the church, but they don't let her lead the choir the first night." In the end, Republicans had little choice. The party stalwarts who were that year's leading contenders for the Republican nomination, Robert Taft and Arthur Vandenberg, were noticeably lacking in that special grace that Americans want in a president.

Willkie's nomination reanimated the Republican brand by presenting a viable alternative to Roosevelt. However, the similarity with Roosevelt that helped propel his candidacy also helped doom it. Even as war raged in Europe, the isolationist wing of the Republican Party insisted that America stay out of foreign affairs. Willkie could never embrace this position, despite dropping some half-hearted hints that he might in order to get elected. This left him at odds with a wing of the party that remained powerful until America's entry into World War II. Whether it was this vulnerability, or Roosevelt's enduring popularity, Willkie lost.

Yet it is hard to keep a good man down. Rather than sulk, Willkie demonstrated a graceful bonhomie after the election. Roosevelt, impressed by Willkie, recruited him to serve as an unofficial ambassador abroad. This unlikely alliance helped make Willkie unpalatable to many Republicans as a candidate in 1944, something the wily Roosevelt probably foresaw.

Heart disease felled Willkie in 1944, at the young age of 52. A year later, Franklin Roosevelt died and was succeeded by Harry Truman of Missouri, a man who was uncannily similar in background and temperament to Willkie. Truman brought to the White House the same Midwestern traits – robust energy and sharp commonsensical intelligence – that Willkie had demonstrated.

Perhaps this is why people kept a place in their hearts for Willkie as they did for few unsuccessful presidential candidates. Willkie personified a uniquely American elan, a cocksure dynamism that Americans admire and which they associate with the country's particular vitality. The best eulogy for Willkie came from one of those unlikely admirers that he had a genius for collecting.

"Americans tend to forget the names of the men who lost their bid for the presidency. Willkie proved the exception to this rule."

Eleanor Roosevelt

Wendell Willkie memorial plaque, New York Public Library | New York, NY

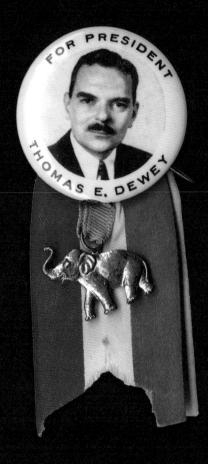

THOMAS DEWEY

Born: 1 9 0 2 Died: 1 9 7 1

1 9 4 4 & 1 9 4 8
REPUBLICAN

Defeated by:
FRANKLIN D. ROOSEVELT
& HARRY S. TRUMAN

A MOST CAPABLE MAN

Si monumentum requiris, circumspice:
"If you seek his monument, look around."

Thus states the epitaph of Christopher Wren, the architect who rebuilt London after the Great Fire of 1666. This pithy phrase encapsulates a school of thought regarding monuments that eschews statues and grand pillars. According to this view, if a man or woman has made an impact on the world, a monument dedicated to that person should instead direct attention to the works the individual left behind.

The Governor Thomas E. Dewey Thruway links the major cities of New York State, connecting Buffalo, Albany, Troy, Utica, and Syracuse with one another, as well as to their big brother to the south. In a state long overshadowed in power, money, and population by the metropolitan behemoth that is New York City, the Dewey Thruway enabled the regions north of the Big Apple to join resources for a more productive and prosperous future. In earlier days, a feeble artery of country roads made much of the state a large Adirondack-ridden nowhere, a rural backwater fit only for dairy farms and summer camps by the lake.

The New York State highway system was only one of the ways Thomas Dewey served the American public in his long career. He began as a crusading special prosecutor whose work brought down corrupt public figures. Later as district attorney, he went after gangsters like Lucky Luciano who fueled that corruption. Dewey's work thrilled the public because, according to his contemporary John Gunther, he "appealed to . . . the great American love of results."

Dewey's particular magic was to make outstanding competence seem almost as compelling as charisma. Of all the Republicans who contended with Franklin Roosevelt for the presidency, Dewey in 1944 came closest to defeating the old lion. It was for this reason that Dewey was re-nominated as the Republican candidate for the 1948 election.

Historians in the last few decades have given Roosevelt's successor, Harry Truman, his deserved status as a stalwart among modern presidents. In 1948, however, Truman was viewed as a nonentity, a placeholder president who would never have been nominated for the Oval Office on his own merits. This sense of being underappreciated galvanized Truman, always an energetic fighter, to campaign as he never had before. Dewey, by contrast, was lulled into doing as little as possible and to treat his ascension to the presidency as inevitable. His complacency showed. While Dewey mouthed banalities during the campaign, Truman barnstormed the country. Harry S. Truman may not have had Roosevelt's grand appeal, but he had a feisty charm. He also had some of the best men in the country in his cabinet: Dean Acheson and George Marshall. Some American voters may have been loath to lose a presidential brain trust of such outstanding talent.

THOMAS DEWEY

Governor Thomas E. Dewey Thruway | NY

Dewey was also hampered by a stiff public persona; in private, he was a warm, hospitable man. In a comment frequently attributed to the caustic Alice Roosevelt Longworth, the well-dressed and thin-mustache-wearing Dewey was compared to "the little man on the wedding cake," a mockery that stuck in the public mind.

We remember the election of 1948 chiefly for an error in which the *Chicago Tribune* went to press announcing a Dewey victory before the polls had closed. Once the results showed a Truman victory, a gleeful Truman took the now-famous photograph with the *Tribune* headline.

Despite Dewey's considerable achievements – including the state university system of New York, and the first state law banning racial discrimination in employment – we remember him today because of a cruel jibe and a newspaper error. What we should remember is that this country once produced so many first-rate leaders that there was not enough opportunity for all of them to become president.

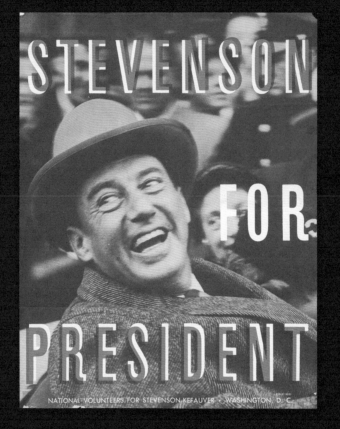

ADLAI STEVENSON

Born: 1900 Died: 1965

1952 & 1956
DEMOCRAT

Defeated by:
DWIGHT D. EISENHOWER

THE GREAT EXCEPTION

For many failed presidential candidates, the judgment of history is harsh and dismissive. If they are remembered at all, it is in a cursory manner: in the back pages of biographies about the men who defeated them, in the footnotes of scholarly monographs, or as the answer to an extra-credit question on AP History examinations.

To be a twice-defeated candidate should logically necessitate a one-way ticket to oblivion, which makes it all the more astonishing that Adlai Stevenson remains both remembered and beloved. He is arguably the most "successful" failed contender for the presidency in American history, the great exception to the rule that also-rans are despised and forgotten.

Which inevitably invites the question, why? Of all the capable, accomplished, and frequently brilliant men who made failed runs at the presidency, why does Stevenson still receive plaudits and encomiums decades after his death? After all, even Stevenson's namesake grandfather achieved higher political office, serving as vice president under Grover Cleveland.

"Cometh the hour, cometh the man." To understand the appeal of Adlai Stevenson, it helps to see him as part of a cohort of candidates who, to their admirers, seemed the ideal presidential choice for the time. When their candidacies failed, their followers placed blame on a foolish, undiscerning electorate and not on the candidate – think William Jennings Bryan or Hillary Clinton.

In the first years following World War II, the United States grappled with its new status as the world's premiere nation-state. Inevitably, the choice of president would shape the leadership America would provide. For many voters, the urbane and articulate Adlai Stevenson, then governor of Illinois, embodied their ideal of an American politician. Blessed with a gift for oratory, a quick wit, and a decidedly upbeat manner, he reminded many Americans of FDR, with Eleanor Roosevelt among Stevenson's most fervent admirers.

In 1952, having occupied the White House for sixteen years, the Democratic Party was searching for someone who could carry on the New Deal legacy started by Roosevelt and continued by Truman. Stevenson, with his reputation as a moderate, was seen as someone who might be able to hold together the factions of Southern conservatives and big-city Northern liberals that constituted the Democratic base. Harry Truman evidently thought so, pleading with Stevenson to pursue the nomination.

Stevenson, the product of a prominent family long involved in Democratic Party politics, had the right pedigree. To Truman's astonishment, however, Stevenson demurred. Part of his resistance, no doubt, was the prospect of running against the enormously popular Dwight D. Eisenhower. However, he was also reluctant to be seen as *interested* in power. He much preferred the thought of being drafted as a candidate at the Democratic convention – seemingly against his will – so as to avoid the perception that he was just another ambitious politician on the make.

He got his wish; the convention nominated Stevenson by acclamation. His acceptance speech was revealing:

"I would not seek your nomination for the Presidency, because the burdens of that office stagger the imagination. Its potential for good or evil, now and in the years of our lives, smothers exultation and converts vanity to prayer. I have asked the Merciful Father . . . to let this cup pass from me, but from such dread responsibility one does not shrink in fear, in self-interest, or in false humility. So, 'If this cup may not pass from me,' I – 'except I drink it, Thy will be done.'"

"*Let this cup pass from me.*" Stevenson's signature style was to act as though he wanted to stand apart from politics, but that his patriotism required him to accept the will of the people. He understood that an essential part of his appeal was the statesmanlike image he projected, of a man upholding the noble traditions of Periclean leadership, motivated solely by love of country and not by personal ambition. (Historians prone to psychoanalytic observation also point to an early trauma where Stevenson accidentally killed a childhood friend with a family rifle. This tragedy, they speculate, left him with a deep ambivalence about wielding great power.)

Despite a devoted base of admirers across the country, he was soundly trounced by Eisenhower, who garnered 442 electoral votes to Stevenson's 89. Normally, that kind of lopsided victory would have been the end of a politician's presidential ambitions, but Stevenson's failure in some way enhanced his status. Winning against Eisenhower, the renowned commander who led the Allies to victory in Europe, was a long shot for any candidate. Four years later, in 1956, many Democrats believed that Americans had tired of Ike and the bland, conformist country his political style seemed to inspire. Voters, especially the young and college-educated, would flock to the polls. They would push out grandfatherly Ike and embrace cool Uncle Adlai. Or so the theory went. In fact, the rematch resulted in Eisenhower winning by an even bigger margin than in 1952.

That drubbing should have been the final nail in the coffin of the "Stevenson for President" movement. Yet even in 1960, a sizable portion of Democratic convention delegates were still devoted to Stevenson and prepared to nominate him a third time, especially with the invincible Eisenhower out of the picture and

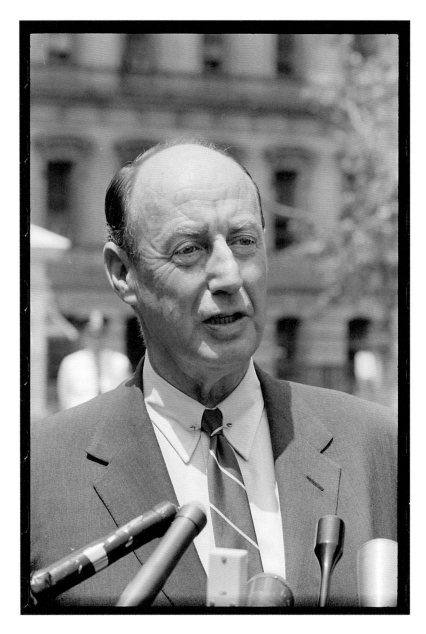

Stevenson speaking at a public event, 1961

the Republican nomination going to the detested Richard Nixon.

The professional class that ran the party machinery, however, was tired of Stevenson. They found his avowed disdain for seeking power a sign of weakness, not a strength. Stevenson's displays of indecisiveness had further eroded his standing among the party elite. Finally, a rising generation of Senate Democrats wanted to step into the presidential arena, men like Estes Kefauver (Stevenson's running mate in 1956), Hubert Humphrey, Stu Symington, Lyndon Johnson and, most importantly, John F. Kennedy.

Kennedy shared many traits with Stevenson: a quick wit, an enchanting eloquence, an ease with intellectuals and big ideas, and an urbane sophistication that many voters admired and aspired to. Moreover, he was seen as having a capacity for decisive action which eluded Stevenson; the influential journalist Joseph Alsop referred to Kennedy as "a Stevenson with balls."

John F. Kennedy's campaign was the best-coordinated and most ruthlessly efficient of the contenders for the 1960 Democratic nomination. His brother and right-hand man Robert had served in Stevenson's 1956 campaign. (Bobby Kennedy became so disillusioned by what he saw as Stevenson's weaknesses that he wound up casting a vote for Eisenhower.) At the 1960 convention, Kennedy supporters blocked an attempt to sway the assembled delegates into giving Stevenson the nomination. After winning the election, Kennedy declined to give Stevenson a significant role in his cabinet, instead making Stevenson the US ambassador to the United Nations. The appointment was far from the most prestigious post Kennedy had to bestow, and it reflected the disdain he privately felt towards Stevenson.

And yet, the U.N. post was perhaps the job that best suited Stevenson, since it gave him a role in which to employ his natural diplomatic abilities and personal charm. He would play one of the most crucial roles in Cold War history when he confronted Soviet U.N. Ambassador Valerian Zorin over Russia's role in the Cuban Missile Crisis. It was Stevenson who suggested to Kennedy the compromise that enabled the crisis to be defused – namely, to agree to remove American missiles in Turkey, close to the Soviet border, in exchange for the Soviets removing the Cuban missiles. The trade was kept a secret, and Stevenson's full role in resolving the crisis was not publicly known until later.

Stevenson continued his U.N. role during the Johnson administration. He died of a heart attack during a visit to London in 1965.

Despite the outsized role he played in mid-twentieth century American politics, there is no great monument to Adlai Stevenson. Admirers and the historically curious have to content themselves with a statue inside the Central Illinois Regional Airport. A bronze representation of Stevenson in a rumpled shirt and loose-fitting tie sits on an airport terminal chair, feet atop a traveling case, his head leaning against his right hand and arm, giving the impression of someone both resting and thinking.

This was the Adlai Stevenson adored by millions: a wise, thoughtful man who seemed both high above and yet comfortable among ordinary citizens, a people's patrician. Stevenson's statue looks like a common traveler waiting patiently between flights – and this is fitting. He was always a man in transit, never arriving at the places he seemed destined for. When Winston Churchill died, Stevenson eulogized him as a giant figure whose death left "a lonesome place against the sky." The same could be said for Adlai Stevenson.

Life-size bronze statue inside Central Illinois Regional Airport | Bloomington, IL

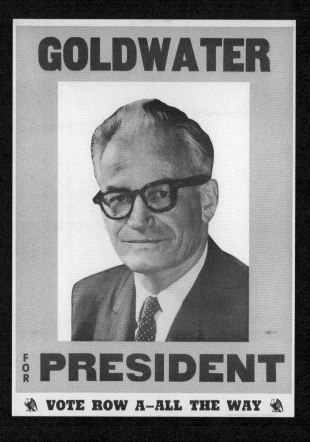

BARRY GOLDWATER

Born: 1909 Died: 1998

1964
REPUBLICAN

Defeated by:

LYNDON B. JOHNSON

NATIVE SON

"In your heart, you know he's right,"

was Barry Goldwater's campaign slogan in 1964.

The Johnson campaign's response was equally pithy:

"In your guts, you know he's nuts."

The truth about Barry Goldwater lies somewhere in between. He could be a speaker of hard truths ("recklessly candid" was the judgment of his *New York Times* obituary). At other times, his fierce adherence to libertarian-conservative principles blinded him. He opposed the Civil Rights Act of 1964 on the grounds that it interfered with state sovereignty, failing to grasp a fundamental truth that millions of his fellow citizens had already comprehended – that protecting basic human rights was more important than shielding states from federal intervention.

Goldwater, like his opponent in the 1964 election, was a son of the American West. Along with great reserves of restless prairie-born energy, both Johnson and Goldwater had a serrated quality to their personalities. Voters often found themselves both drawn to the energy and repelled by the roughness of each man.

Inevitably, they were overshadowed by smoother, more telegenic men. Johnson struggled mightily to avoid being eclipsed by the legacy of John F. Kennedy, who started out the political equivalent of a movie star and ended up a mythological figure. Goldwater, in turn, had to stomach being displaced in the hearts of conservatives by an actual movie star, Ronald Reagan, who understood better than Goldwater that, when promoting conservatism, it was more effective to be a sunny salesman than a grumpy scold.

Goldwater was also a victim of bad timing. If the extreme poverty of the Great Depression had fueled a liberal spirit of "pull together" in the policies of Franklin Roosevelt's New Deal, post-WWII American prosperity and power helped create a feeling of largesse, a sense that the abundance could and should be shared, an attitude best expressed by Johnson's "Great Society." During this period of liberal dominance in national politics, Goldwater was the lonely voice of "cut-back" conservatism, an angry desert prophet, who became John the Baptist to Reagan's convivial Jesus figure – best remembered for paving the way for the Chosen One.

Given the political momentum given to Johnson by the 1960s political *zeitgeist*, and by the national outpouring of sympathy and support he gained by inheriting the mantle of the murdered JFK, Goldwater's campaign was fated to be a long shot. It wasn't helped by his tin ear to unintended ways in which his words could be interpreted. Of all the things he said and wrote, few are as well remembered as his campaign statement: "I would remind you that extremism in the defense of liberty is no vice. And let me remind you also that moderation in the pursuit of justice is no virtue."

It was intended to echo a quote from Cicero. Had the American electorate consisted of classically educated voters, it might have been a winning line. As it was, it seemed less a defense of liberty than a justification for extremism – disturbing in more sedate times, but particularly alarming in a country where the Cuban Missile Crisis was a recent memory.

BARRY GOLDWATER

Barry Goldwater Memorial | Paradise Valley, AZ

Such remarks gave the Johnson campaign a green light to run the infamous "Daisy" advertisement. A young girl counts the petals she picks from a flower, only to be interrupted by an adult's voice counting down to a missile launch followed by the image and sound of a nuclear detonation. The screen cuts to a black background followed by words in white letters, "Vote for President Johnson on November 3rd," and a deep-voiced narrator portentously intoning, "The stakes are too high for you to stay home."

Barry Goldwater was thus cast as Dr. Strangelove. Thanks to such tactics, so overwhelming was Johnson's victory that Goldwater was not a serious contender for the 1968 presidential election, helping to pave the way for Richard Nixon's return to the national scene. Together with the escalation of the Vietnam War, this must be accounted as Lyndon Johnson's other great political sin.

Goldwater returned to the Senate, where his bluntness and gravity naturally suited him to the role of elder statesman. (It was Goldwater who delivered the news to President Nixon that it was time for Nixon to step down.) In later years, Goldwater would assert his crusty independence by disagreeing with the direction of conservative politics in America. He deplored the rise of the religious right's influence in the Republican Party, and opposed bans in the military restricting the right to serve only to heterosexual Americans. With true Western horse-sense, he said, "You don't need to be 'straight' to fight and die for your country. You just need to shoot straight."

Goldwater's memorial in Paradise Valley, Arizona, is a bronze statue on a simple platform, only a foot off the ground, surrounded by the desert under a clear blue sky. His right elbow and left knee are angled, suggesting a person in motion, moving forward with confidence.

Goldwater would have appreciated that touch. For him, conservatism was not a life-denying philosophy, but one that equipped men and women with hardscrabble truths to better prepare them for the vicissitudes of life. In Goldwater's eyes, political programs that encouraged dependence on government, even when well-intentioned, were ultimately corrosive, robbing people of a sense of what they could accomplish on their own, or in cooperation with their closest neighbors.

Deserts breed an understanding of the scarcity of resources. Goldwater's monument is so minimalist that one's attention cannot help but take in the sparse vegetation that surrounds it. Abundance, it seems to say, is a temporary state, and one should never make plans based upon it. It is a sentiment that Barry Goldwater would have appreciated.

Back view of Barry Goldwater Memorial

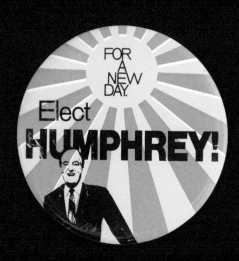

HUBERT H. HUMPHREY

Born: 1911 Died: 1978

1968
DEMOCRAT

Defeated by:
RICHARD NIXON

THE HAPPY WARRIOR

The Hubert H. Humphrey Terminal. The Hubert H. Humphrey Job Corps Center. The Hubert H. Humphrey School of Public Affairs. The Hubert H. Humphrey Bridge. The Hubert H. Humphrey Comprehensive Health Center. The Hubert H. Humphrey Recreation Center. The Hubert H. Humphrey Elementary School (two of them). The Hubert H. Humphrey Middle School. The Hubert H. Humphrey Building of the Department of Health and Human Services. No less than thirteen public works have been named for the former senator from Minnesota.

The many recognitions bestowed on Humphrey are a testament to his legacy, which represented the postwar liberal impulse at its finest. Born in 1911 and raised in South Dakota, Humphrey went to Minnesota for college and, excepting a brief return to South Dakota to help with his father's pharmacy business, remained a Minnesotan for the rest of his life. In his congeniality and civility, he personified "Minnesota nice."

That was both Humphrey's strength and his weakness.

After a stint as a political science professor at Macalester College, Humphrey began his career in politics in 1945 as the mayor of Minneapolis. He made his first mark on national politics as a delegate to the Democratic National Convention in 1948, the same year he was elected to the Senate, with a rousing speech in support of a civil rights platform – in open defiance of the powerful Dixiecrat contingent, Southern delegates who had long prevented Democrats from advancing any serious civil rights legislation. "The time has arrived in America for the Democratic Party to get out of the shadow of states' rights and to walk forthrightly into the bright sunshine of human rights." The pro-civil rights plank went forth – and the Southern delegates went out, leaving the convention and nominating Strom Thurmond as the candidate of the new States' Rights Democratic Party.

Humphrey's efforts on behalf of civil rights marked him as one of a new generation of Democrats who embraced Roosevelt's New Deal vision and wanted to move beyond it to create a bolder, more inclusive vision for the country. His energy and talents were recognized during his three terms in the Senate, including a role as Majority Whip from 1961 to 1964.

He made his first attempt at the Democratic presidential nomination in 1952. While he got his name on the ballot, all the serious contenders that year were old lions of the party. Humphrey did not pursue the nomination again until 1960, when the moment finally arrived for the younger generation to step forward and claim the presidential mantle. Humphrey's candidacy, like others, quickly fell to the unstoppable and ruthless juggernaut of the Kennedy campaign.

Remaining in the Senate, Humphrey's liberalism made him a natural ally of Kennedy's "New Frontiersman." The impetus for the Peace Corps, for example,

began with a bill Humphrey sponsored in 1957. After Kennedy's death, Humphrey became a key figure in the Senate who, as Majority Whip, was able to push forward the Civil Rights Act of 1964.

Humphrey's nickname in the Senate was "the happy warrior" to acknowledge his particular combination of passionate advocacy for liberal causes and his gift for collegiality with all his fellow senators. This, and his status as a senator from the Midwest, made Humphrey a logical choice as Lyndon Johnson's running mate in 1964. Humphrey could be the leavening sweetness to counteract the often sour, abrasive nature Johnson displayed in strong-arming other politicians into supporting him and his policies.

Humphrey's desire for the presidency had not abated. As one of the few non-millionaires in the Senate, he would never have the personal resources that were an increasingly vital component of a presidential campaign. One time-honored, if imperfect, path to the Oval Office lay through the vice presidency. Lyndon Johnson, who understood this line of thinking perfectly, shrewdly realized that Humphrey would be an effective (and easily dominated) running mate.

Acceptance of a place on Johnson's ticket came at a steep cost. Despite his own deep-seated anger at being treated dismissively as Kennedy's vice president, Johnson had no qualms about treating Humphrey as a lackey, expected to do the president's bidding without question. One early low point occurred during the 1964 Democratic Convention when Humphrey was required to block the seating of black delegates from Mississippi to accommodate the wishes of white delegates from the same state. Johnson wanted to avoid controversy in order to achieve a smooth convention and ensure his nomination.

It was a grim foreshadowing of other compromises Humphrey would have to endure. As a lifelong liberal, he was happy to work on Johnson's Great Society programs, but contention over the Vietnam War soon eclipsed domestic legislative successes. Liberal Democrats, who had briefly embraced Johnson over the success of the Civil Rights Acts of 1964, quickly turned against him. Despite misgivings, Humphrey felt compelled to support Johnson's aggressive war policies. This support eroded his prestige with the left, who now saw him as a spineless sellout.

1968

The 1968 race for the Democratic nomination was tumultuous. Johnson, entitled to run again, bowed out. Humphrey was left to contend with a challenge from fellow Minnesotan Senator Eugene McCarthy, representing the anti-war wing of the party, as well as the charismatic Robert Kennedy. Kennedy's assassination that summer further fueled the downward spiral of a Democratic Party split by warring factions. In the end, Humphrey would win the nomination at the infamous convention in Chicago remembered for angry protesters and police brutality.

The country, tired of the turmoil destabilizing the country, awarded the presidency to Richard Nixon. Despite Humphrey's costly loyalty to Johnson, even Johnson privately admitted he preferred Nixon, whom he saw as having the stamina to continue the war in Vietnam until an American victory could be achieved.

Humphrey returned home to Minnesota. In another twist, Humphrey's former opponent Eugene McCarthy decided not to run again for his Senate position. Humphrey campaigned and won the seat, returning to the Senate. He had not abandoned his hopes for another run at the presidency by 1972, but when he was soundly defeated by George McGovern in the race for delegates, he knew his presidential ambitions were truly over. Like Barry Goldwater, Humphrey continued on as a public servant emeritus; honored, if no longer powerful, he was elected the Senate's first deputy president pro tempore. Bladder cancer cut short his second career in the Senate; he died at home in Waverly, Minnesota, in 1976 at the age of 66.

Hubert Humphrey's idealism, energy, and willingness to work with others across the table made him the model of the principled politician thriving in a healthy political culture where bipartisanship was the norm, not the exception. However, his willingness to be accommodating – particularly to Lyndon Johnson – also doomed his hopes for the presidency.

Despite this failure, Humphrey left a legacy of public service only partly captured by the buildings and structures that bear his name. His spirit and inexhaustible good cheer reflected both his personal temperament and his ultimate faith in what American democracy could achieve.

Hubert H. Humphrey Federal Building | Washington, D.C.

As his wife Muriel remarked: "Sometimes I felt discouraged, but Hubert never did."

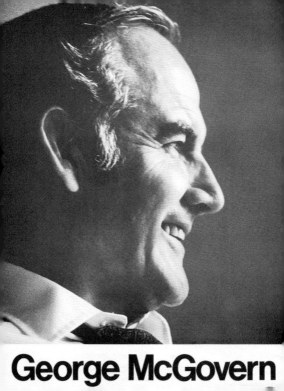

George McGovern

GEORGE McGOVERN

Born: 1922 Died: 2012

1972
DEMOCRAT

Defeated by:
RICHARD NIXON

THE STANDARD-BEARER

George McGovern's role in American political history is, in a perverse way, similar to that of King Duncan in Shakespeare's tragedy Macbeth – a largely secondary figure brought down by a devious, ambitious politician whose Machiavellian machinations prove self-destructive. In much the way Duncan's murder plants the seeds for Macbeth's downfall, the 1972 break-in at the Watergate headquarters of the Democratic National Committee set into motion the destruction of Richard Nixon's presidency, despite Nixon's overwhelming electoral victory.

The irony, of course, is that the underhanded and illegal tactics of Nixon's operatives were unnecessary; McGovern's own poorly managed campaign would have been enough to ensure a Nixon victory. McGovern ruefully acknowledged a year after his epic loss, "For many years, I wanted to run for the Presidency in the worst possible way – and last year I sure did."

1 9 6 8

George Stanley McGovern, who spent most of his political career as a senator from South Dakota, shared many qualities with fellow Midwesterner Hubert Humphrey. Both men were products of a culture that favored hard work and self-reliance, but both had also seen the devastating effects of poverty on people disadvantaged through no fault of their own. Each man embraced the New Deal philosophy and its implicit belief that government had a role to play in ensuring all Americans had some resources to help them get started and move forward in life.

In the late 1960s, a division arose between the men that symbolized the disruption in the Democratic Party's liberal wing. McGovern had become one of the most acerbic critics of the war in Vietnam and what it was doing to the country. Humphrey, though he may have privately agreed with McGovern, felt compelled to remain loyal to the hawkish position endorsed by Lyndon Johnson. This split led to the disastrous 1968 convention in Chicago, an event marred by violence and conflict between pro-war and anti-war factions and overshadowed by the recent assassination of Robert Kennedy, the one figure who may have unified the party.

McGovern did not win the nomination in 1968, but threw his hat into the ring again in 1972. By then, much of the country approved of the work being done by President Nixon. A sign of trouble for McGovern was difficulty in recruiting a running mate. Several prominent Democrats – doubtlessly sensing Nixon's momentum – refused the position. McGovern settled on Senator Thomas Eagleton from Missouri; on the surface, a logical choice given that he was from a Southern state. However, it was discovered that Eagleton had received electroshock therapy in the past to help him combat depression. The failure to properly vet Eagleton reflected badly on McGovern. The choice of a running mate is a candidate's first presidential-level decision, and a poor choice can leave a candidate looking incompetent.

Eagleton withdrew, but the damage was done. Nixon went on to win the 1972 election in an Electoral College landslide, 520 votes to McGovern's 17. McGovern was seen as the ultimate political loser. Worse, he was perceived as a standard-bearer for the basic values of his party, and his loss was seen by some as rejection of liberal-centrist politics. For years afterwards, Republican politicians would attempt to associate their Democratic opponents with a "McGovernite" label. As

GEORGE McGOVERN

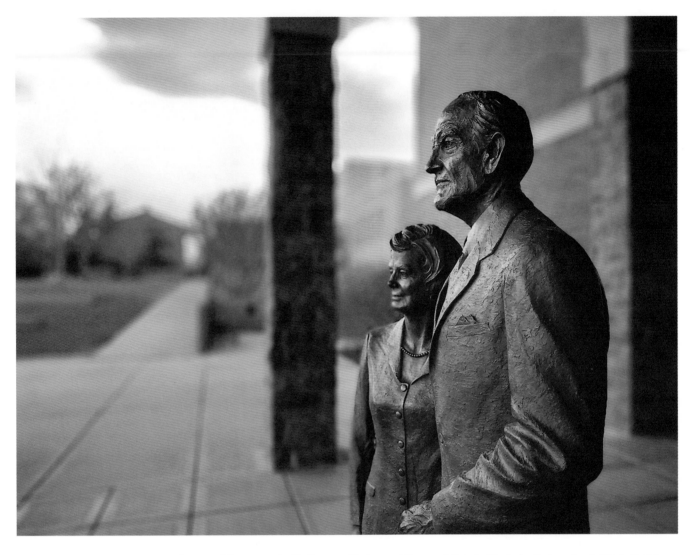

Statue of George and wife Eleanor, McGovern Library at Dakota Wesleyan University | Mitchell, SD

Chicago columnist Bob Greene wrote, "Politicians – mostly Republicans, but some Democrats, too – are using his name as a synonym for presidential campaigns that are laughable and out of touch with the American people."

McGovern continued in the Senate until being defeated in the "Reagan Revolution" of 1980. Thereafter he worked for a number of private organizations related to public policy. He died in a South Dakota hospice in 2012.

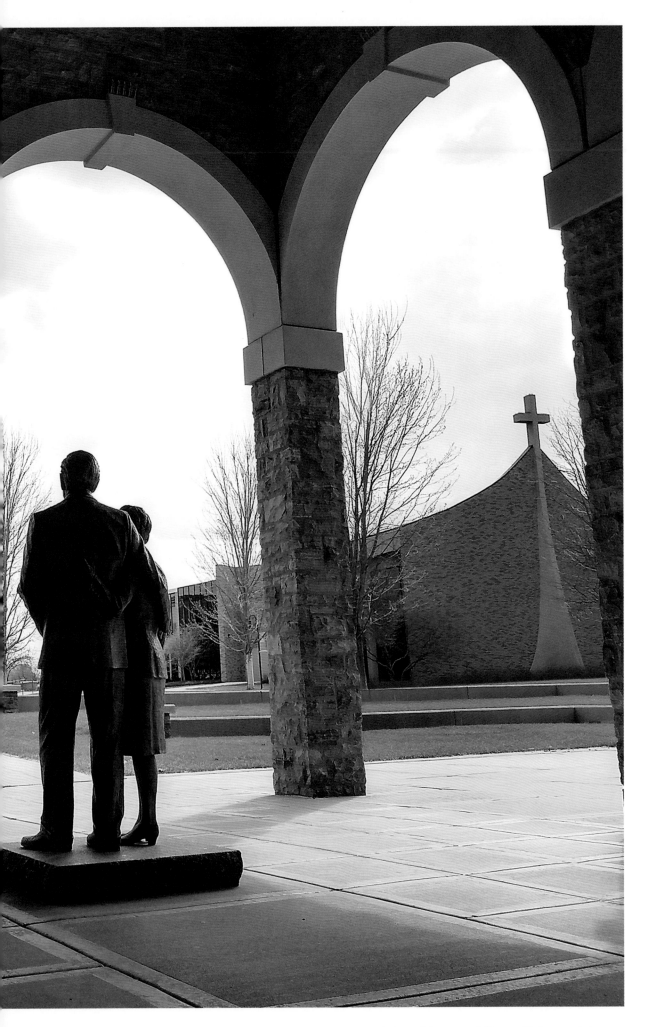

Back view of George and Eleanor McGovern statue

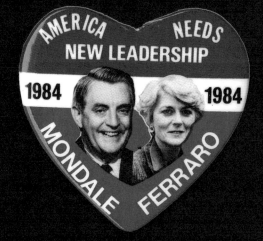

WALTER MONDALE

Born: 1928

1984
DEMOCRAT

Defeated by:
RONALD REAGAN

THE WINGMAN

It is a paradox of American politics that to be as close as possible to the presidency without being president requires occupying a position noted for its passivity, where one's most important duty is to remain ready to assume the presidency and little else. What's more, vice presidents are expected to be completely deferential to the presidents they serve, actively subordinating themselves to a more dominant figure. It's as if the office of vice president was designed to weaken its occupant.

Consequently, earning a reputation as a perfect vice president can be a detriment to one aspiring to the presidency. The career of Walter Mondale offers a cautionary tale for anyone pursuing the presidency through the second highest office in the land.

Mondale, a native of Minnesota and a lawyer, began his career in politics as a protege of Hubert Humphrey, whose Senate seat he was appointed to when Humphrey assumed the vice presidency. Mondale served twelve years in the Senate before being selected by Jimmy Carter to be his running mate. Apart from the geographical diversity Mondale added to the ticket, his reputation for integrity, hard work, and modesty appealed to Carter. In addition, he was not seen as someone who would overshadow his president, a very appealing quality in a vice president.

Carter, to his credit, recognized how thankless the traditional role of vice president was for a talented, intelligent politician and worked to make it more active. One important change was to give Mondale an office in the White House – the fact that no previous vice president had a White House posting speaks volumes. Carter and Mondale had an unusually effective working partnership, and Carter entrusted Mondale with a variety of responsibilities that helped redefine the role and served as a model for subsequent vice presidencies.

As a result, however, Mondale was closely associated with Carter's presidency, which was then regarded as a well-intentioned failure. After Carter's defeat in 1980, Mondale resumed the practice of law but quickly returned to the political stage in the 1984 presidential race. He secured the Democratic nomination, although given the considerable popularity of Carter's successor, Ronald Reagan, it was rather a hollow victory.

Mondale's campaign is memorable for two reasons: one, he selected Geraldine Ferraro as his running mate, the first woman on a major-party presidential ticket. Second, he attempted to connect with the electorate by being bracingly honest about his plans to reduce the budget deficit. During a campaign speech, he vowed that "By the end of my first term, I will reduce the Reagan budget deficit by two-thirds. Let's tell the truth. It must be done, it must be done. Mr. Reagan will raise taxes, and so will I. He won't tell you. I just did." Mondale, like Jimmy Carter in the latter's infamous "malaise" speech, overestimated the appeal of blunt candor to the electorate. If anything, he wound up reminding people why they had voted Carter out of office.

He also managed to give Reagan, a gifted public speaker, the opportunity to wittily deflect accusations that at 73, he was too old to continue as president (Mondale

Walter F. Mondale Hall, University of Minnesota Law School | Minneapolis, MN

was 56 at the time). When Mondale raised the issue of fitness during a debate, Reagan responded with, "I will not make age an issue of this campaign. I am not going to exploit, for political purposes, my opponent's youth and inexperience."

The election of 1984 handed the Democrats an even greater defeat than the Republicans had experienced with Barry Goldwater in 1964. Reagan took every state but Minnesota, which stayed loyal to its native son. As a consequence, Mondale's career as an elected politician was over. However, his sagacity and experience were put to good use by President Bill Clinton, who appointed Mondale as ambassador to Japan from 1993 to 1996.

Mondale made a brief attempt to return to elected office, running in the election to fill his old Senate seat vacated upon the death of Senator Paul Wellstone in 2002. Mondale lost that election – thus earning the dubious distinction of having lost an election in all 50 states – and again returned to private life, filling a variety of advisory and public service roles.

Mondale is most often remembered for his trouncing by Reagan in 1984. His greatest legacy, however, is the way he helped reinvent the job of the vice presidency from a passive observer of important political action to an active partner in the running of the country.

MICHAEL DUKAKIS

Born: 1933

1988
DEMOCRAT

Defeated by:
GEORGE H.W. BUSH

THE PROBLEM SOLVER

To be American is to live with a tension between aspiration and reality. Raised in the belief that our republic is a unique beacon of liberty to the world – in the words of Abraham Lincoln, "the last best hope of earth" – we are constantly reminded how often we fall short of our national ideals, burdened by the knowledge that there is a gap between who we should be and who we are.

Consider the lineage of our chief executives. For a country that defines itself as a nation of immigrants, only eight of its presidents (as of 2017) could claim an immigrant parent, most of whom came from Great Britain. In truth, for much of our history, native-born Americans have regarded Americans born in other countries with suspicion, seeing them as unwelcome aliens coming to compete for jobs, outsiders undermining our national values with their strange, foreign ways.

Consequently, the ascension in 1988 of Michael Dukakis as the choice of the Democratic Party for president was a watershed moment. The son of two immigrants from Southern Europe, Dukakis's selection signaled the maturation of a country that had long preferred its national leaders to be descended from purely Anglo-Saxon origins.

Yet as much as Dukakis was publicly seen as "the immigrants' son," his success in politics had more to do with movement away from the reliance on ethnic coalitions that had defined Democratic Party politics in major urban areas for the better part of the late nineteenth and twentieth centuries. Given the complex problems facing the country, Democrats needed leadership with a fresh vision that moved beyond the political orthodoxies of the past.

Born in Brookline, Massachusetts, Michael Dukakis was the second child of two Greek immigrants, his father Panos a Harvard Medical School-trained physician. A star academic pupil in high school, Dukakis attended Swarthmore College, then enlisted in the army. Following a tour of duty in Korea, he attended Harvard Law School. During this time, he wooed and married Kitty Dickson Chaffetz, a fellow Brookline resident.

He made his first attempt at public office while still in law school, running for a seat on the Brookline Redevelopment Authority. While he did not win that position, he ran successfully the following year for a seat as a member of the Brookline Town Meeting, the local legislature.

Dukakis belonged to a generation of young Democrats inspired first by Adlai Stevenson and then John F. Kennedy; Kennedy, in particular, their beau ideal. Like many of them, Kennedy had clear roots in the immigrant wave that had reshaped American politics over the previous hundred years. However, Kennedy had transcended parochialism to emerge as a model new Democrat, one who appreciated the past but grasped that present problems required creative thinking and, with brisk self-confidence, was willing to dismiss old approaches and experiment with fresh ideas.

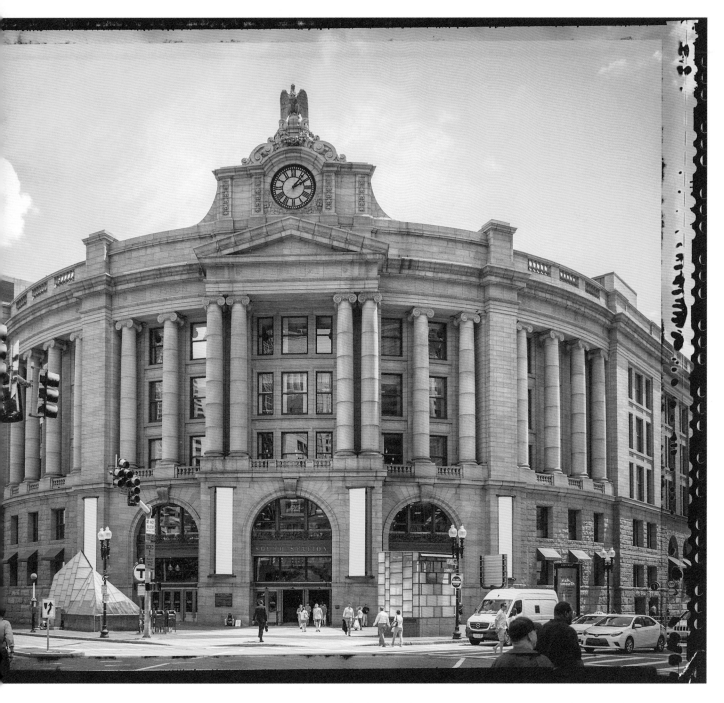

Governor Michael S. Dukakis Transportation Center at South Station | Boston, MA

Dukakis was elected to the Massachusetts state legislature in 1962, part of a group called the Commonwealth Organization of Democrats (COD), an association of reform-minded Democrats aiming to replace a state establishment infamous for its cronyism. During his eight years in the Massachusetts State House, Dukakis impressed his peers with his intelligence, diligence, hard work, and mastery of policy detail. He led the passage of the country's first no-fault auto insurance bill. In 1967 he was voted most outstanding legislator by his House colleagues in a survey conducted by the New Bedford *Standard-Times*.

Despite his successes, Dukakis was hampered by a perception that he was arrogant and aloof. He was prone to lecturing colleagues. Adverse to a political culture that thrived on backslapping and cutting deals in smoke-filled rooms, Dukakis avoided making the personal connections that others saw as essential to effective politics. He was, he admitted in later years, "not a good listener," adding that "I really did not understand that getting things done in the public sector is all about building coalitions."

In spite of these shortcomings, Dukakis was a natural selection for lieutenant governor alongside Kevin White, the popular mayor of Boston. While White and Dukakis lost the 1970 election, the exposure helped Dukakis four years later when he ran for governor, defeating incumbent Francis Sargent.

Dukakis's first term as governor showcased his administrative abilities. Inheriting a state deficit larger than anyone realized, Dukakis was bold enough to make the deep cuts necessary to save the state from bankruptcy, even if it meant alienating many of his most liberal supporters. He also made the difficult decision to raise taxes in spite of a campaign pledge. Both decisions cost him politically. However, crisis was averted, even leading to a budget surplus a few years later. His managerial skill was also on display in 1978 when he helped shepherd the state through the worst blizzard Massachusetts had seen in decades.

The successes of his first term were enough to make Dukakis and his supporters confident of his renomination as the Democratic gubernatorial candidate in 1978. However, there were warning signs they did not heed. The business community regarded him as unfriendly, even as the state economy picked up. In addition, in his zeal to remove patronage from the culture of Massachusetts politics, Dukakis

offended a number of allies who felt penalized by a governor going out of his way to demonstrate that his friends could expect no special favors. Finally, many legislators still regarded Dukakis as cold and patronizing.

Whatever the ultimate cause, Dukakis had left himself vulnerable to challenge. He went into the primary complacent, and was stunned when Ed King, a classic backslapping, dealmaking Irish American, beat him in the Democratic primary and went on to win the governorship. "It was like a public death," his wife Kitty would later recall.

Having lost a job he felt supremely suited for, Dukakis was forced into a period of painful reflection. He took a position teaching public policy at the Harvard Kennedy School of Government. Discussing the nature of public service with students contributed to Dukakis's difficult but necessary self-assessment.

Four years later, a chastened and wiser Dukakis challenged Governor King for the nomination in what would be known as "the rematch." King's administration had been plagued by ineptitude and scandal, which made voters appreciate the integrity and competence Dukakis had demonstrated during his time in office. Dukakis won the Democratic primary and defeated his Republican opponent that November, returning to the governor's office in 1983. For the next four years, Dukakis oversaw growth in his state so impressive it was dubbed "the Massachusetts Miracle." His relationships with the business community markedly improved. Successful initiatives for getting welfare recipients into the workforce and for encouraging tax evaders to pay their share were praised and seen as models that could be replicated nationally.

It was perhaps inevitable that in 1988, having lost the previous two national elections, Democrats would turn to someone like Dukakis with a record of tackling tough problems and finding workable solutions. While Dukakis was a much-admired governor, however, he was not nearly as well-known as his Republican challenger, George H.W. Bush, who had the advantage of eight years as vice president to the enormously popular Ronald Reagan. Moreover, Bush had played a conspicuously executive role in the last two years of Reagan's administration as Reagan, worn down by age and scandals such as the Iran-Contra affair, began to withdraw from active involvement in the presidency.

Bush, with his sights on the presidency for much of his political career, took no chances. He employed Lee Atwater, an exceptionally aggressive campaign manager, to portray Dukakis as soft on hardened criminals and prone to raising taxes. Dukakis ran a cautious campaign and did not respond quickly or aggressively enough to the negative charges. He was also plagued by the old charge of being insufficiently empathetic. During an election debate, when asked how he would regard the death penalty if his wife was raped and killed, Dukakis's response cited statistics pointing to the ineffectiveness of the death penalty as a crime deterrent. It struck many as academic and detached.

Dukakis gained momentum in the final weeks of the campaign, but he could not overcome Bush's lead. Bush won both the popular and Electoral College votes, although the degree to which his campaign had struck a negative note overshadowed his victory. Bush would never command the popularity that Reagan enjoyed and, four years later, was rejected by voters in favor of Bill Clinton, a young technocrat whose approach as Arkansas governor was much like the model Dukakis had developed in Massachusetts.

Dukakis returned to Massachusetts to complete his term as governor. He opted not to run for re-election in 1990 and instead returned to teaching, dividing his time between Northeastern University and UCLA to work with college students interested in public service. He has also served on the board of Amtrak, reflecting his ongoing interest in public transportation. In 2014, South Station, the largest public transportation hub in Boston, was renamed the Governor Michael S. Dukakis Transportation Center. In addition, a center for public policy at Northeastern University was named for Dukakis and his wife Kitty.

While Dukakis did not achieve the presidency, he helped fashion the mold for the generation of politicians to follow him into state and national office. For a man seen as lacking the personal touch, Dukakis has been an outspoken advocate of returning to door-to-door campaigning as a way of connecting with people. Given the way an overdependence on data models and analytics left Democrats stunned by their defeat in 2016, they would do well to consider his advice.

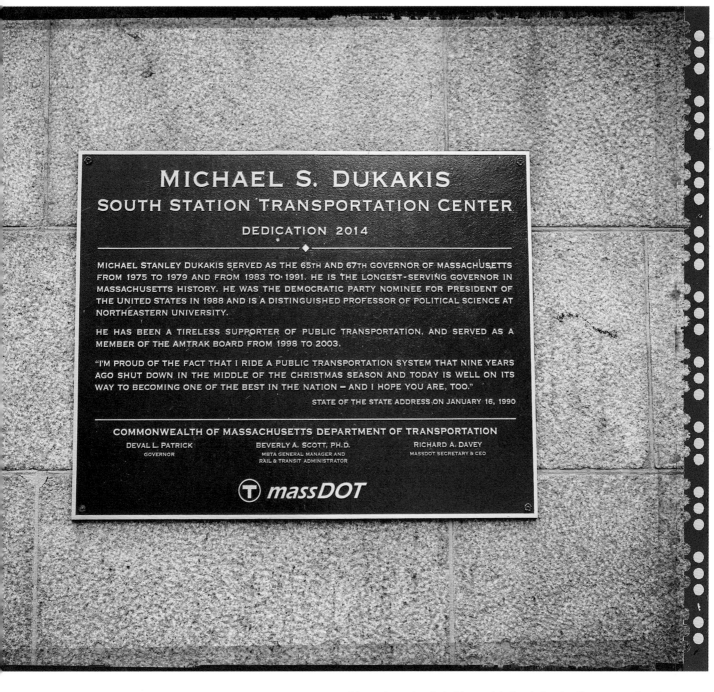

Plaque honoring Dukakis outside South Station Transportation Center

BOB DOLE

Born: 1923

1996
REPUBLICAN

Defeated by:
BILL CLINTON

THE PARTY ELDER

Each of the first three centuries of US history has a generation that stands apart, sacrificing themselves to, as Thomas Jefferson phrased it, refresh the "tree of liberty." The generation that struggled in the American Revolution was followed in the nineteenth century by the soldiers who fought to save the Union and, in the words of Lincoln, by their sacrifice gave the "last full measure of devotion." Their successors in the twentieth century fought in Europe, North Africa, and the Pacific during World War II and, decades later, were dubbed "The Greatest Generation."

1996

Unlike their predecessors, the Greatest Generation inherited a United States that was the world's leading power. Their crucible was a war fought on foreign soil, which helped shape their perception of America's role in the wider world. The national leadership they provided in the post-World War II years was a defining element of what has sometimes been called the American Century. The last of their members to seek the presidency was Bob Dole.

Robert "Bob" Dole of Kansas had served thirty-six years in Congress – eight as a congressman and twenty-eight as a senator – before he became the Republican Party candidate for president in 1996. At the time, he was one of the most respected Republicans in national government, the Senate leader for his party since 1985. Like his friend and occasional rival George H.W. Bush, Dole was a Republican party stalwart and an accomplished political administrator, though not seen as possessing the charisma Americans tend to look for in their presidents. Unlike Bush, Dole had to run against a sitting president. Bill Clinton, at that point, still enjoyed a positive relationship with the American public; the Lewinsky scandal which would tarnish his reputation was a few years away.

Initially, Dole had reason to be hopeful, given that Democrats had lost control of both the House of Representatives and the Senate in the 1994 midterm elections. However, recovery from the economic recession of the early nineties helped strengthen Clinton's position. He wound up winning by a comfortable margin in both the popular and electoral votes.

Dole handled his defeat with the stoic grace one would expect from a decorated World War II combat veteran; he was on television within a week of his defeat joking about his loss. Since that election he has lived in quiet retirement with his wife Elizabeth. While he did not achieve the presidency, his many years of principled leadership, combined with a willingness to seek constructive compromises with political opponents, led to the creation of the Dole Institute, a bipartisan institution devoted to promoting awareness and understanding of politics in a democratic society. In 2018, Bob Dole was awarded the Congressional Gold Medal.

Robert J. Dole Institute of Politics, University of Kansas | Lawrence, KS

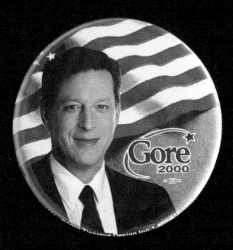

AL GORE

Born: 1948

2000
DEMOCRAT

Defeated by:
GEORGE W. BUSH

THE ALMOST PRESIDENT

To lose a presidential campaign itself is a heavy blow. Imagine the pain of knowing that, if all votes were carefully counted, you may in fact be the victor.

Two presidential candidates, both Democrats, experienced just this tribulation. In 1876, Samuel Tilden conceded the presidency in exchange for the removal of federal troops from the South, ensuring the region's electoral loyalty for close to 100 years – a price well worth paying. When a contested election occurred again in 2000, there was no political prize to console the defeated candidate, other than the sense that he had spared the country the polarizing trauma of an uncertain outcome.

Al Gore belonged to that class of men groomed by their fathers to become president of the United States. The first was John Quincy Adams, the son of the second president of the United States and one of the country's founding fathers. Gore, by comparison, was merely the offspring of an ambitious senator from Tennessee, Al Gore, Sr., who had raised his son as a member of the political establishment. The younger Gore, after graduating from Harvard University in 1969, allowed himself to be drafted into the US Army despite his anti-war opinions because he did not want to jeopardize his father's political career.

On his return from the Army in 1971, Gore attended divinity school and worked as an investigative reporter in Tennessee before starting Vanderbilt University Law School. He dropped out of Vanderbilt to run for his father's old seat in the House of Representatives. Gore was elected and, like his father, spent several years in the House before gaining a seat in the Senate. During these years Gore was seen as a moderate with a passion for technology issues; he belonged to a group known as the "Atari Democrats." He was a leader in promoting legislation around telecommunications issues and was an early adopter of the phrase "information superhighway."

Gore made his first attempt to run for president in 1988. At 39, he was seen as young and promising, but not ready for the presidency. Speculation circulated that Gore would make a good vice-presidential running mate for a more seasoned candidate.

Another professional interest that Gore developed was a focus on environmental issues. After a serious accident involving his son sent Gore into a period of deep reflection, he wrote *Earth in the Balance,* his first book and first significant foray into the relationship between global ecology and politics.

In 1992, breaking from a tradition of choosing running mates from other parts of the country, Governor Bill Clinton of Arkansas tapped Gore as his VP choice. Gore's experience in Washington and with foreign policy added a level of national expertise that Clinton lacked. Their victory over President George H.W. Bush ended twelve years of Republican control of the White House and marked the first presidency whose chief figures were shaped by the politics of the Vietnam War era, the first presidential ticket composed entirely of baby boomers.

AL GORE

Clinton gave Gore greater scope and responsibility than traditionally afforded to vice presidents. Although Gore was seen as a natural successor, astute observers noted that Clinton's most senior advisor was his wife Hillary. As early as the 1990s, Hillary Clinton was mentioned as a possible future candidate for the presidency; however, tradition and protocol favored giving Gore a chance to succeed Bill Clinton.

The general quiet and prosperity of the 1990s gave Gore a legacy to run on. It might have been an easy path to the presidency, if not for the sex scandal that rocked the Clinton administration's final years. Bill Clinton had an affair with a young intern in his office, then attempted to cover it up with deceptive language. There had always been something reckless about the politically gifted Clinton, but it had been assumed that his worst qualities had been contained. The Lewinsky affair proved otherwise, and a sense of profound disappointment dimmed the power of the Democratic ticket, even though Clinton's folly was no personal reflection on Gore.

While Gore lacked Clinton's self-destructive tendencies, he also lacked Clinton's charisma. Gore impressed people as a dependable, stolid person, much the way George H.W. Bush had under Ronald Reagan. He had supporters, but did not generate the excitement that voters often want in a presidential candidate.

The challenge to Gore for the presidency came from the son of the man pushed out of office by the Clinton-Gore ticket in 1992. George W. Bush was a generational peer of both Clinton and Gore. Growing up in Texas, the younger Bush possessed a greater ability to connect with ordinary voters than his patrician father had. Bush even managed to win Gore's home state of Tennessee in the 2000 election.

The pivotal state was Florida, with its 24 electoral votes. At first the state seemed to go to Bush, ending the election; Gore even called Bush to concede. It quickly became clear that the voting tally had been ineptly managed, however, and Gore's campaign called for a recount that left the country uncertain as to who would be the next president. The question was finally settled when the Supreme Court ruled the recount unconstitutional. In the final count, Gore had won the popular vote, but lost the vote in the Electoral College. While disappointed with the court's decision, he accepted it in order for the country to move forward.

In the years following the 2000 election, Gore reinvented himself by becoming a leading spokesman for global warming awareness, releasing the powerful and widely seen *An Inconvenient Truth,* the first documentary to win two Oscars. For his efforts to address global climate change, he was the co-recipient of the 2007 Nobel Peace Prize.

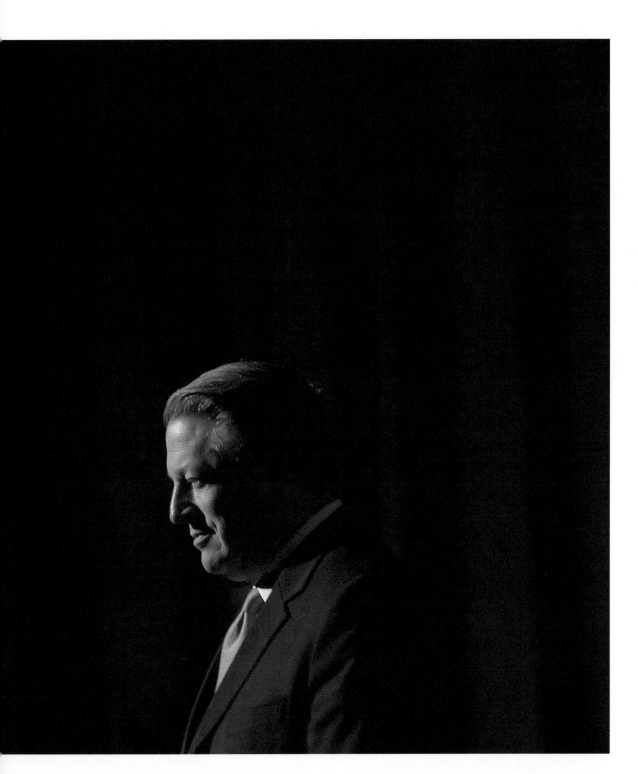

Gore at a 2006 screening of *An Inconvenient Truth*

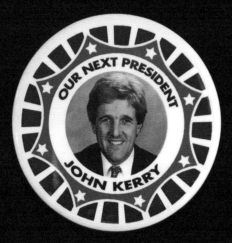

JOHN KERRY

Born: 1943

2004
DEMOCRAT

Defeated by:
GEORGE W. BUSH

LIBERAL PATRICIAN

Napoleon Bonaparte once said that an important quality in successful generals is luck; the same can be said of politicians. At 18 years old, just before going off to Yale, John Kerry dated Janet Auchincloss, the half-sister of then-First Lady Jacqueline Kennedy. This brief relationship led to an invitation to sail with John F. Kennedy on his yacht off the coast of Massachusetts. The experience was captured in a photo of young Kerry seated in a white shirt while the president of the United States, surrounded by friends, steers the ship.

Any association with JFK is worth a king's ransom to a Democratic politician, especially one who runs for office in Massachusetts. In many ways, Kerry was seen as a continuation of the Kennedy legacy – a liberal Ivy Leaguer, a patrician who sought to be the voice of ordinary working people.

After finishing his degree at Yale, Kerry joined the Navy and served on a swift boat, a small cruising vessel not unlike the PT boats where Kennedy had served during World War II. After completing his military service, he unsuccessfully ran for a seat as state representative from Lowell, Massachusetts. Kerry attended Boston College Law School and served in positions that kept him close to political circles. In 1982, he became lieutenant governor of Massachusetts under Michael Dukakis, and in 1984 ran successfully for the Senate seat being vacated by Paul Tsongas. Kerry would serve as a senator from 1985 to 2013.

In 2004, he won the Democratic nomination to challenge Republican incumbent George W. Bush. Initially, Bush's people were concerned that Kerry's record as a decorated Vietnam veteran would work against the president. Bush, in stark contrast to Kerry, had used his family's influence to gain a stateside posting in the Alabama National Guard during the Vietnam War. However, Kerry was unable to turn his record as a naval commander to his advantage the way John F. Kennedy had. Even worse, Republican operatives recruited former naval men who had served alongside Kerry to criticize him and suggest that he was an inadequate leader; *Unfit to Command* was the title of a campaign book written against him. This maneuver added the phrase "swiftboating" to the political lexicon, meaning an unfair attack.

Kerry never mastered the skill of responding artfully to political attacks, preferring to ignore or dismiss them. This did not help his campaign against Bush. While both men came from privileged backgrounds (both attended Yale and were members of the elite fraternity Skull and Bones), Bush cultivated a more accessible public persona, while Kerry was perceived as congenial but formal and stiff. After being defeated by Bush, Kerry returned to the Senate. While he considered another run in 2008, he left the field open to other prominent candidates such as Hillary Clinton and Barack Obama. In 2013, he was appointed Secretary of State for Obama's second term, replacing Hillary Clinton. After Obama left the White House, Kerry retired from politics.

American swift boat river patrol, circa 1969 | Vietnam

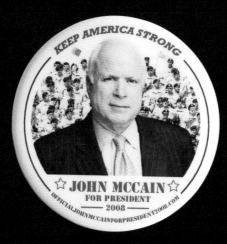

JOHN McCAIN

Born: 1936 Died: 2018

2008
REPUBLICAN

Defeated by:
BARACK OBAMA

THE POW

When Barack Obama campaigned for president in 2008, much was made of the fact that he had spent four of his formative years outside the continental United States, much of it in Asia. In an increasingly globalized world where wealth was shifting from the West to the East, this experience was seen in some circles as a major advantage for someone aspiring to the presidency. Coincidentally, his Republican opponent had also spent several years living in Asia, but under entirely different circumstances.

John McCain spent five years in Vietnam as a prisoner of war in the internment center dubbed "the Hanoi Hilton," forging a complex connection between McCain and Vietnam which in some ways was more important to his life than Indonesia was to Barack Obama. Prior to his capture, McCain was seen as reckless, a carefree and entitled member of the naval aristocracy, the son and grandson of four-star admirals with major commands in the Pacific. Five years as a prisoner of war, with long stretches in solitary confinement interrupted by violent interrogations, were bound to leave a mark. That McCain was able to recover from that experience and lead the full life he did is a testament to the fact that he possessed the same essential toughness that had marked the lives of his father and grandfather.

John McCain was born in the Panama Canal Zone when it was still under United States control. He was raised in Virginia and, like his father and grandfather, attended the US Naval Academy. Showing the rebellious streak that would mark his entire life, the young McCain flouted protocol and did not apply himself to his studies, graduating close to the bottom of his class (894th of 899). He trained as a naval aviator and was commissioned as an ensign.

His first brush with danger came aboard the aircraft carrier USS *Forrestal*, assigned to the Pacific theater during the Vietnam War. McCain was on deck when a faulty bomb detonated, setting off a chain reaction of explosions that resulted in the deaths of 134 Navy personnel (fortunately for McCain, he was able to get out of his plane with some quick thinking). He was reassigned to the carrier USS *Oriskany*, from which he flew a series of combat missions over North Vietnam. He was flying an A-4E Skyhawk in 1967 when an anti-aircraft missile struck his plane. He ejected and was captured by North Vietnamese civilians, who beat him before turning him over to authorities.

At first, McCain was treated as roughly as any captured American pilot. But the Vietnamese soon learned that McCain was the son of Admiral John McCain who, in 1968, was appointed Commander-in-Chief of the Pacific Command, the supreme commander of American forces in Southeast Asia. They offered the younger McCain early release, which would have been a propaganda coup for them. However, he refused to leapfrog over other American prisoners captured earlier than himself – a refusal which did not endear him to his captors and led to even harsher treatment.

Navy destroyer USS *John S. McCain* | South China Sea

He managed to survive his years in captivity and returned home to a hero's welcome in March 1973. In the early years of his career, he had married a divorcee named Carol Shepp, with whom he had two stepchildren and a biological daughter. Upon his return from Vietnam, however, McCain began a series of affairs, one with a young heiress named Cindy Lou Hensley. He and Carol eventually divorced, and he married Hensley. Despite the ease with which McCain might have attributed his failings to his experience as a POW, he later acknowledged that the collapse of his first marriage was due to "selfishness and immaturity more than it was to Vietnam, and I cannot escape blame by pointing a finger at the war. The blame was entirely mine."

After his return to active duty, McCain became the Navy's liaison to the Senate. Finding the political arena more suitable to his ambitions than the Navy, McCain resigned from the service and successfully campaigned as a Republican for a seat in the House of Representatives from Arizona, the home state of his second wife. He served four years in the House before successfully pursuing a vacancy in the Senate left by the retirement of Barry Goldwater.

As a former POW and staunch Reagan Republican, McCain had a charmed political life, but it was almost derailed by his association with Charles Keating. A banker who had helped fund McCain's campaigns, Keating was the head of a savings and loan that collapsed in the late 1980s, wiping out the funds of thousands of customers. The Senate's ethics committee cleared McCain of wrongdoing in the matter, and from that point on, his political career moved ahead smoothly. His independent streak and openness to bipartisan deals led him to acquire the nickname "Maverick," a moniker associated with Tom Cruise's character in the iconic film *Top Gun* about a charming naval fighter pilot.

With the end of the Clinton administration, McCain's opportunity to become president was never better. During his years in Washington, he had cultivated the press with rare skill, charming them with calculated bluntness. In addition, his bipartisan work made him a Republican acceptable to some Democratic voters. Unfortunately for McCain, he had opposition from another son of the establishment: George W. Bush, governor of Texas and son of President George H.W. Bush. Although McCain's "Straight Talk Express" campaign helped him win New Hampshire, Bush defeated him in the South Carolina primary. A series of further primary defeats followed, and McCain lost the nomination to Bush, who would go on to serve as president for eight years.

When George W. Bush's time had passed, McCain tried again and in 2008 won the Republican nomination. However, by this point, the country had been governed by a Republican for eight years, and momentum for change now favored a Democrat. Moreover, his election opponent was not the one he had anticipated, his friend Hillary Clinton, but a young senator from Illinois who had served only a few years in Congress before making a play for the presidency. Barack Obama had a rare, quiet charisma. Just as important, his campaign portended the changing racial demographics in America.

Recognizing the cultural forces favoring his opponent, McCain became desperate not to fail in his second attempt to become president. As detailed in the book *Game Change,* McCain gambled on a running mate that would make his ticket seem more in tune with the times. At first glance, Alaska Governor Sarah Palin seemed an inspired choice; however, it soon became clear that Palin had a polarizing effect. She had a tendency to make outrageous, unsupportable claims that incensed many voters who, thus galvanized, supported the Democratic ticket.

Despite the pressure of the campaign, McCain was able to maintain an essential dignity and civility that won the admiration of people on both sides of the political divide. When a woman at a McCain rally claimed that Obama, whose middle name was Hussein, was an "Arab" – a clumsy attempt to suggest that he was in sympathy with Muslim extremists – McCain corrected her. "No ma'am," replied McCain. "He's a decent family man, citizen, that I just happen to have disagreements with on fundamental issues."

McCain's defeat in 2008 ended his hopes for the presidency. He remained in the Senate, supporting Mitt Romney in 2012. However, at a time when he should have enjoyed the status of an esteemed statesman, he was instead fending off challengers in his own party who reflected the drift away from the center-right where McCain had made his career. Perhaps worse, in 2016 he had to endure insults from Donald Trump, then campaigning for the presidency. McCain had criticized Trump, and Trump responded by deriding McCain's years as a prisoner of war: "He is a war hero because he was captured. I like people who weren't captured."

McCain never hid his disdain for Trump. For the most part, however, McCain tried to avoid unnecessary conflicts after the latter was elected, since so much of the Republican base had become strong Trump supporters.

McCain was diagnosed with brain cancer in 2017 and died a year later. His funeral became a rallying point for members of the older political establishment, Republican and Democrat, who detested Donald Trump. Speaking at the funeral, his daughter Meghan McCain made an implicit comparison between her father's vision of the country and Trump's by saying, "The America of John McCain has no need to be made great again because America was always great."

MITT ROMNEY

Born: 1947

2012
REPUBLICAN

Defeated by:
BARACK OBAMA

THE MORMON

In the body of work devoted to the study of American presidential campaigns, the documentary *Mitt* stands out as a unique contribution. It provides an unusually personal look into the life of a candidate for president of the United States. The film's most interesting moments are not the actual campaign stops, but the backstage moments that capture the strain of being a presidential candidate in an age of frenzied media coverage.

One of the most poignant moments occurs when, as election results come in, it becomes increasingly clear that Romney will lose to President Obama. His wife Ann sits stone-faced, the room silent. Romney, his own crushing disappointment apparent, still feels the urge to be the comforting *paterfamilias* and in an attempt to lighten the mood, half-jokingly inquires whether anyone has the president's phone number.

Mitt Romney was born in 1947 as the youngest child of George Romney, a prominent businessman and devout Mormon who served as president and chairman of the American Motors Corporation before becoming governor of Michigan. Decades before the Osmond family, George Romney's success in the most quintessential American industry had helped reform the general perception of Mormons as a strange, heretical offshoot of Christianity. As such, the Romneys were held in high esteem by the LDS community; Mitt's mother Lenore ran for a Senate seat from Michigan in 1970.

Mitt Romney's early life followed the dutiful path of a young Mormon: private school, then Stanford University followed by a few years as an LDS missionary in France. (If any experience helped Mitt Romney to develop tact and diplomacy, it was surely the years he spent pitching abstinence from smoking, caffeine, and alcohol to the French.) When Romney returned to the United States, he renewed his relationship with a young woman named Ann Davies, who converted from the Episcopalian faith to Mormonism in order to marry him. They settled in the Boston suburb of Belmont while Romney completed his combined studies at both Harvard Law and Harvard Business School.

After graduation, Romney joined the Boston Consulting Group as a manager, emerging as one of its rising stars. A few years later he joined Bain & Company, where he would eventually rise to CEO. From there he would launch Bain Capital, an investment firm which would become extremely successful. Romney's gifts as a manager and investor made him his own fortune – by some estimates, a quarter of a billion dollars, enough for him to donate his entire inheritance from his parents to Brigham Young University. While pursuing his business career in Massachusetts, he also served as bishop for his local LDS ward.

In 1968, Romney's father made a run at the Republican nomination before losing to Richard Nixon, followed by a term in Nixon's cabinet as Secretary of Housing and Urban Development. Mitt wished to follow his father's path from business into politics and made an attempt to unseat Ted Kennedy as a Massachusetts senator in 1992. Challenging a Kennedy in Massachusetts takes nerve, and although he lost that race, he raised his profile enough to make him a contender for other political opportunities.

He further burnished his reputation as a manager of unusual skill when he took over the 2002 Winter Olympics in Utah, which seemed as though they were becoming a financial boondoggle. Romney steered the Winter Olympics into a smooth operation which ended with a $100 million surplus. (Critics accused Romney of exaggerating the problems faced by the Olympic committee in Utah in order to enhance his reputation as the man on the white horse.)

In 2002, Romney ran for and won the Massachusetts governorship; again, his timing seemed propitious. Although often seen as a Democratic stronghold, Massachusetts residents have a history of favoring Republican governors, as long as they were not doctrinaire conservatives and could bring the state's budget into line after years of runaway spending. Romney helped balance the budget and, in a feat that gained him admirers from both sides of the political fence, helped broker a statewide health insurance arrangement – dubbed "Romneycare" – that created a model for other government health care initiatives. Paradoxically, that same achievement would cause him problems a few years later.

Romney declined to run for a third term as governor, instead throwing in his hat for the Republican presidential nomination in 2008. However, it was deemed to be John McCain's time in the ring. When McCain lost to Obama in 2008, Romney began thinking about 2012.

His patience paid off, and he was able to secure the party's nomination in 2012. But the political mood had changed in the interim and the party's base, now more strongly to the right, never warmed to Romney, whose politics seemed more driven by pragmatism than strong ideological convictions. Worse, Romneycare was seen by diehard Republicans as a prototype for the despised Obamacare program, a comparison Democrats gleefully played up.

Romney's inability to connect with the Republican base was evident at a campaign stop where supporters chanted the name of Romney's running mate Paul Ryan. Romney, almost pathetically, had to remind the voters to chant his name as well. For all his hard work, ability, and basic decency, Mitt Romney could never forge a connection with a large enough bloc of voters. His defeat by Barack Obama, in this light, was not surprising.

After the election of Donald Trump in 2016, Romney (who had criticized Trump) was rumored to be a possible contender for Secretary of State, but this proved illusory. It was not until 2019, seven years after his failed run for the presidency, that Mitt Romney first served in the federal government, as a senator from Utah.

MITT ROMNEY

Mitt Romney was both the beneficiary and victim of timing. His Mormonism, which would have made him unacceptable to his party's more traditional Christian base in earlier decades, was no longer a real issue. However, his country-club brand of Republicanism belonged to a more relaxed and secure era. For many Americans, it seemed antiquated and out of place in an age of anxiety.

Romney at a 2012 campaign event | Milwaukee, WI

HILLARY CLINTON

Born: 1947

2016
DEMOCRAT

Defeated by:
DONALD TRUMP

HITTING THE GLASS CEILING

November 9, 2016, was supposed to be a historic turning point. For the first time, a woman would be the elected leader of the most powerful country in the world. It would signify an important moment in cultural and political evolution, a great leap out of the male-dominated political order that has been the norm for the vast majority of tribes and nations since the beginning of recorded history.

The assumption of imminent victory by the female candidate was strengthened by the general view of the opposing candidate, a New York real estate developer and reality television star with no experience in elected office whose combative, bombastic personality was offensive to people across the political spectrum. Media commentators expected election night to be a boringly predictable affair. The *New York Times* gave the female candidate an eighty percent chance of winning.

But a funny thing happened on the way to the White House. On election night, the former senator and Secretary of State with years of experience in government, whose victory was considered a certainty, began to lose ground to the real estate developer. By evening's end, the world was in shock as Donald Trump, best known for shameless self-promotion and saying, "You're fired" to television contestants, was elected the 45th president of the United States. And his opponent, Hillary Clinton, so confident of victory that she had not prepared a concession speech, was forced to accept the crushing disappointment of political ambitions born half a century earlier, at a time when Americans first began to seriously consider the possibility that a woman could become president.

Hillary Rodham was born in Chicago, the daughter of two people whose political allegiances were firmly Republican. In her earliest years, she accepted her parents' political beliefs, to the point of joining the Young Republicans when she first started at Wellesley College in Massachusetts. However, like many who came of age in the late 1960s, Rodham gravitated towards the burgeoning women's rights movement and moved away from her Republican roots to the Democratic Party.

She attended Yale Law School, where she met Bill Clinton. After graduation, she accepted his marriage proposal and accompanied him back to his native Arkansas. It had been assumed that she would embark on an ambitious career path of her own; many friends and fellow students were surprised when she opted for a more traditional role and subordinated her own career to her husband's goals. Bill Clinton won the governorship of Arkansas in 1978 and except for a brief time out of office, he would serve as governor until mounting a successful challenge to President George H.W. Bush in 1992.

The years of Bill Clinton's presidency were years of relative prosperity as the United States enjoyed political dividends from the collapse of the Soviet Union and the end of the Cold War. Her husband's presidency gave Hillary Clinton an opportunity to engage in policymaking by spearheading an initiative

to provide more comprehensive government-supported health care, long a significant goal for the Democrats.

The fight against what was dubbed "Hillarycare" was more acrimonious – and personal – than she likely anticipated. Republicans were well aware of the potential influence wielded by a power couple like the Clintons. ("You get two for the price of one!" Bill Clinton had boasted during his first presidential campaign.) They attacked Hillary Clinton as an unelected interloper in government, far more activist than first ladies were supposed to be. It did not help that Hillary Clinton lacked her husband's easygoing charm. She often displayed a tough, assertive manner that was off-putting to some people. Like Thomas Dewey, her public image concealed the more human side that she displayed in her private life.

"Hillarycare" went down in defeat in Congress. It was the first in a series of setbacks for Hillary Clinton, culminating in the tawdry Monica Lewinsky scandal which revealed that Bill Clinton, long rumored to be a serial philanderer, had seduced a White House intern. The ensuing uproar led to President Clinton's impeachment trial and sapped his effectiveness in the final years of his second term. Despite what was doubtless an extraordinarily painful period, Hillary Clinton chose to remain with her husband, a decision which diminished her standing with admirers who saw her as capitulating to the regressive role of a dutiful wife enabling her husband's bad behavior.

With Bill Clinton's presidency over and their daughter Chelsea fully grown, Hillary was free to finally pursue her own political ambitions. In 2000, she and Bill moved to New York State in order for Hillary to run for the Senate seat being vacated by the retiring Daniel Patrick Moynihan. She was elected the first female senator from the state of New York. Hillary served in that post for eight years before launching her own campaign for president in 2008.

By this time, Hillary Clinton was an acknowledged star in her own right within the Democratic Party. After eight years of a Republican administration, a devastating recession, and a failed war in Iraq, Hillary Clinton and her supporters saw the moment as perfect for her to rekindle the progressive spirit of her husband's time in office. In this she was probably correct; however, she failed to anticipate the sudden rise of a new star in the Democratic firmament. Barack Obama, a senator

from Illinois, quickly captured the spotlight. Apart from his charisma, he had impressed many Democrats by having the courage to vote against the resolution to go to war with Iraq. Hillary had voted for the war; some assumed that it was to convey toughness and resolve in preparation for her own presidential run. Equally important, Obama had none of Clinton's baggage. After a spirited primary competition, the 2008 Democratic Party nomination went to Obama, who went on to defeat Republican challenger John McCain.

As part of a deal to ensure Hillary's full support during the general election, she was offered the role of Secretary of State in the new administration – an ideal posting to help position her to succeed Obama. When the moment arrived in 2016, the Democratic Party establishment was prepared to grant her the nomination virtually uncontested. What they – and Clinton – could not have anticipated was a serious challenge from someone who wasn't even officially a member of the party.

Senator Bernie Sanders, elected from Vermont as an independent, was too far to the left to fit neatly into the center-left party fashioned by the Clintons and their allies in the 1990s. Instead, he embodied the rising, rough-hewn spirit of unapologetic left-wing politics that the Clintons thought had been purged from most of the Democratic base. The disruptions brought about by the Great Recession, the impact of globalization, and the effects of social media on public discourse tossed the old political rule book out the window. Sanders captured the imaginations of many voters in a way that Hillary Clinton found difficult to match.

Despite the formidable challenge posed by Sanders, Clinton went on to secure the Democratic nomination. Meanwhile, a similar disruption by an outsider had taken place on the Republican side. Donald Trump, real estate developer and part-time reality television star, had managed to upend the Republican contest. His unfiltered language and often offensive behavior, which in earlier years would have doomed his campaign from the start, caught the attention of a Republican base just as fed up with the establishment as their Democratic counterparts. To the amazement of millions, Trump won the Republican nomination.

Hillary Clinton and her supporters were delighted at that outcome, assuming (as did the political pundit class) that Americans would not recklessly elect someone who had behaved as outrageously as Trump during the campaign. Trump had no

previous experience with political administration. Surely, his nomination was an outlier event, an aberration to be explained in the future by political scientists.

Clinton, like many of her peers in the political and media establishments, did not fathom the depth of anxiety and anger burbling beneath the surface of the electorate. She failed to make significant inroads with voters in swing states like Pennsylvania and Ohio. For all her political experience, Hillary Clinton never displayed the same intuitive understanding of working-class voters as her husband, who had come from the lower middle class. Worse, she insulted many of the people drawn to Trump's blunt talk by referring to some of them as "a basket of deplorables." Instead, she depended on the coalition of voters emerging in the Democratic Party between comfortable suburban middle-class voters and minority groups drawn to the inclusive vision of a new America that Democrats promised, and which the election of Barack Obama seemed to herald.

On November 8th, 2016, the polls were very favorable to Clinton. Early voting patterns did not suggest anything unexpected, but as the night went on, Donald Trump began to gain momentum. The election results prediction needle on the website of the *New York Times* began to quiver, then slowly move away from Clinton. By the end of the evening, Trump was ahead in electoral votes, although Clinton had a clear lead in the popular vote. When Trump amassed the necessary electoral votes to declare himself president-elect, it was a greater political upset than the 1948 election, when Harry Truman defeated Thomas Dewey.

No one was more shocked than Hillary Clinton, who was unable to deliver the traditional concession speech and instead sent campaign manager John Podesta to inform supporters that the fight was over.

The upset of the 2016 election was so great that Hillary Clinton became the first unsuccessful candidate to write an entire book explaining her failure to become president. *What Happened*, published in 2017, was regarded by reviewers, even ones sympathetic to Clinton, as disappointing. "The Hillary Clinton of this bitter memoir," wrote a reviewer in the *Washington Post*, "resembles the shrunken, beaten Richard Nixon who told David Frost that he gave his enemies a sword and 'they twisted it with relish.'"

For some, Hillary Clinton will always be the woman who first came close to breaking the glass ceiling separating female politicians from the country's highest office, a role model who maintained astonishing composure in the face of innumerable challenges and personal attacks going back decades. For others, she is a baby boomer elitist with a sense of entitlement, out of touch with the lives of ordinary people. Perhaps there is truth in both views.

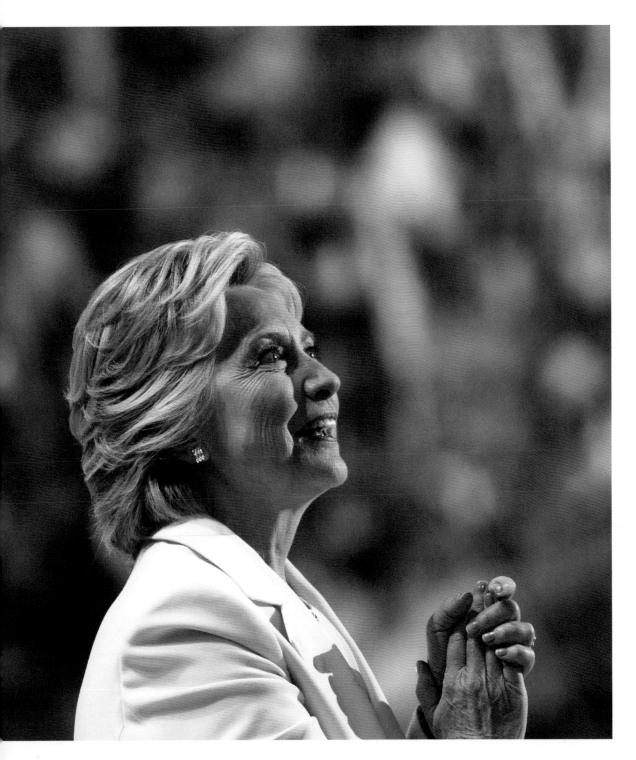

Clinton accepting the 2016 Democratic nomination | Philadelphia, PA

★ IN THE ★
ARENA

PETER SHEA

Peter Shea has been a writer, editor, and teacher for over 25 years, and a history geek for far longer. He has written about prominent Irish Americans, educational gaming, and cutting-edge technologies in higher education. Peter is a Learning and Development Professional at the community college level. *In the Arena* marks his return to the subject of public lives in America.

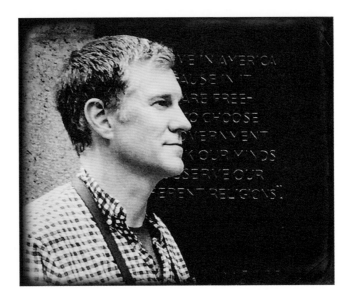

TOM MADAY

Tom Maday is a photographer whose assignments take him to every corner of the globe for a variety of commercial and editorial clients. His pictures appear in the books *Trope Chicago, Trope London, Great Chicago Stories,* and *After the Fall: Srebrenica Survivors in St. Louis.* Tom is happy for the opportunity to work on a project that combines two primary interests: American history and photography.

ACKNOWLEDGMENTS

While the idea for a book may originate with one or two people, the creation of a book requires more than that. To quote one of our book's subjects, "It takes a village." In the spirit of gratitude and community, we wish to extend special thanks to Governor Michael Dukakis and Dr. James Kelly for believing in this project, and for adding their unique perspectives. Thanks also to Jim Grenier for his assistance in connecting us with Governor Dukakis.

Thank you to Tom Maloney for taking the beautiful photographs for the chapters on George McGovern and Walter Mondale. Thank you to Leo Maday for joining many of the expeditions to locate and effectively capture these far-flung monuments and memorials. And thank you to Maureen Frazell for her careful review of early drafts, which led to improved content and smoother overall flow.

And, finally, we would like to thank the Trope editorial team, including Sam Landers, Lindy Sinclair, Jack Van Boom and Scott Yanzy, for improving *In the Arena* every step of the way, and for making this book possible in the first place.

Peter Shea & Tom Maday

A NOTE ABOUT THE PHOTOGRAPHS

In an effort to capture the temporal spirit of the monuments photographed for this book, the images were digitally filtered with Exposure Software to emulate various films and photographic processes. Some of the algorithms we have used replicate the look of calotypes, cyanotypes, daguerreotypes, and wet plates using collodion process on glass negatives.

Photos not specifically credited were taken and edited by Tom Maday and the Trope Publishing team.

PHOTO CREDITS

John W. Davis	**150**	Harris & Ewing, ca. 1905; Library of Congress, Prints & Photographs Division
John W. Davis	**153**	The Washington Post / Stephanie Gross / Getty Images
Al Smith	**154**	Samuel Johnson Woolf, 1928; National Portrait Gallery, Smithsonian Institution
Alf Landon	**162**	Division of Political and Military History, National Museum of American History, Smithsonian Institution
Alf Landon	**165**	Anderson Hall, courtesy of Kansas State University
Wendell Willkie	**166**	Campaign poster, 1940; Library of Congress, Prints & Photographs Division
Thomas Dewey	**172**	Division of Political and Military History, National Museum of American History, Smithsonian Institution
Adlai Stevenson	**176**	Division of Political and Military History, National Museum of American History, Smithsonian Institution
Adlai Stevenson	**180**	Warren K. Leffler, 1961; Library of Congress, Prints & Photographs Division
Barry Goldwater	**184**	Amalgamated Lithographers of America, 1962; National Portrait Gallery, Smithsonian Institution
George McGovern	**196**	Division of Political and Military History, National Museum of American History, Smithsonian Institution
George McGovern	**199**	Photo by Tom Maloney, used with permission
George McGovern	**200**	Photo by Tom Maloney, used with permission
Walter Mondale	**202**	Division of Political and Military History, National Museum of American History, Smithsonian Institution
Walter Mondale	**205**	Photo by Tom Maloney, used with permission
Bob Dole	**217**	Dole Institute; from www.wikimedia.org, © 2017 Amfeather. Used under Creative Commons Attribution-Share Alike 4.0 International License; https://creativecommons.org/licenses/by-sa/4.0/deed.en / Cropped and filtered.
Al Gore	**222**	The Sydney Morning Herald / Adam McLean / Fairfax Media via Getty Images
John Kerry	**227**	NH 95842, courtesy of the Naval History & Heritage Command
John McCain	**231**	Navy photo by Petty Officer 3rd Class James Vazquez; The appearance of U.S. Department of Defense (DoD) visual information does not imply or constitute DoD endorsement.
Mitt Romney	**238**	Justin Sullivan / Getty Images
Hillary Clinton	**246**	The Washington Post / Getty Images

Photographs © 2021 Tom Maday
except as otherwise credited

Book design by Jack Van Boom

LCCN: 2020940011
ISBN: 978-1-7320618-3-5

Printed and bound in China
First printing, 2021

INFORMATION:
For additional information
about Trope Publishing Co.,
visit www.trope.com